DIGITAL LANDSCAPE PHOTOGRAPHY *step by step*

MICHELLE PERKINS

AMHERST MEDIA, INC. ■ BUFFALO, NY

To Mom and Dad for long family car trips to some beautiful places,
and to Paul for putting up with quick photo trips that end up taking hours.

Copyright © 2005 by Michelle Perkins
All rights reserved.

Published by:
Amherst Media, Inc.
P.O. Box 586
Buffalo, N.Y. 14226
Fax: 716-874-4508
www.AmherstMedia.com

Publisher: Craig Alesse
Assistant Editor: Barbara A. Lynch-Johnt

ISBN: 1-58428-151-0
Library of Congress Card Catalog Number: 2004101354

Printed in Korea.
10 9 8 7 6 5 4 3 2 1

Notice of Disclaimer: The information contained in this book is based on the author's experience and opinions. The author and publisher will not be held liable for the use or misuse of the information in this book.

Table of Contents

PLEASE NOTE!

If you flip through this book, you'll notice that the pages are not numbered. Instead, each two-page lesson is numbered sequentially on the left-facing page. The numbers that are listed in the table of contents and index (as well as the cross-references within the text) also refer to these same lesson numbers.

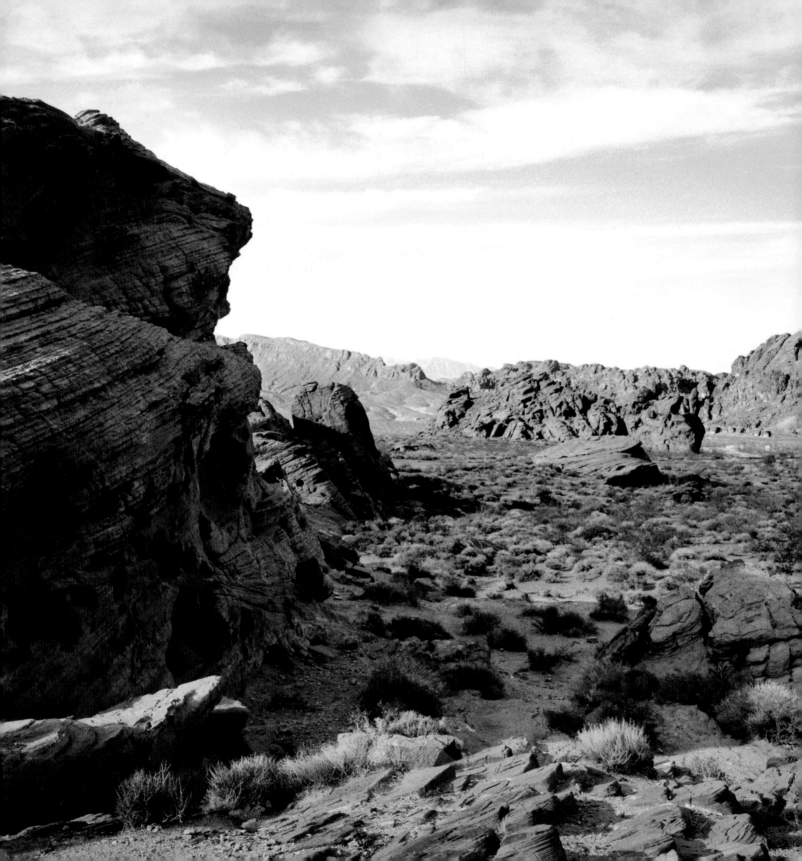

Introduction

From grand vistas, to stunning skylines, to the familiar tranquility of a backyard garden, we all witness scenes on an almost daily basis that would make memorable landscape images. With digital technology, these are now easier than ever to photograph.

However, capturing the majesty of even the most breathtaking scenes is still far from simple (in fact, sometimes the more amazing a scene is, the harder it is to do it justice). If you just "point and click," you'll capture only the most rudimentary representation of your subject. Not only will these images fall short of capturing the scene as you experienced it, they will also fail to communicate your sense of the scene to people who see your images.

Digital landscape photography is challenging, but the results can be quite rewarding.

Fortunately, help is a few short lessons away. This book is arranged a little differently than other instructional books you might have read in the past. Designed for quick learning, each lesson has been condensed down to two quick-to-read pages—so you can peruse them quickly and start putting the techniques to use right away in your own images.

If you flip through the book, you'll also notice that the pages are not numbered. Instead, each two-page lesson is numbered sequentially on the left-facing page. The numbers listed in the table of contents and index (as well as the cross-references within the text) refer to these lesson numbers.

Although the lessons are numbered, you don't have to read them in order. If you do so, you'll get a complete overview of the concepts of landscape photography. If you prefer a more "organic" learning experience, though, you can skip around and find the techniques that most appeal to you (or answer your individual questions).

Landscape photography is an extremely challenging artistic pursuit, and practicing regularly is the best way to improve your results. Therefore, to make the most of your learning experience, be sure to get out and actually try the techniques. Remember, it doesn't cost you a penny to take even a terrible photo with your digital camera, so experiment while you're out shooting and take the time to carefully review your results when you get home.

Most of all, have fun and be creative. For millennia, landscapes and the natural world have fascinated artists working in all media—so you're in very good company.

1. Digital Camera Basics

As with film cameras, there are several types of digital cameras. You can do landscape photography with any type—and you don't need to use the latest, greatest model—but some types and models of cameras do offer features that make them more flexible than others.

POINT-AND-SHOOTS

The most common type of digital camera among nonprofessionals is the point-and-shoot. This type of camera has a built-in lens, fully automatic exposure and focusing, and an image sensor (the "film" of the digital camera) in the 2–6 megapixel range.

For landscape photography, it is helpful to use a model with a zoom lens, since this will give you the most choices when composing your images. It is also helpful to have a full range of exposure-mode settings (like landscape, aperture/shutter priority, etc.—we'll be discussing these in more detail in lesson 19). Being able to select your aperture and shutter speed manually are also helpful, as is the option to focus manually (although this can be so

A point-and-shoot digital camera can produce excellent landscape images.

tricky to adjust on point-and-shoots that you may find it too frustrating to use very often).

Look for a model that allows you several choices of white-balance settings (including the option to create a custom setting). This will be discussed in greater detail in lesson 30.

Finally, it is very helpful if the camera allows you to use photographic filters over the lens (see lesson 3).

All of the major camera manufacturers—Kodak, Sony, Fuji, Nikon, Canon, etc.—make excellent cameras, so shop by feature rather than by brand name if you decide to purchase a new camera.

DSLRS

DSLRs (digital single-lens-reflex cameras) are the most common type used by professional photographers. Because camera manufacturers have noticed consumer interest in this type of

> ### HOW MANY MEGAPIXELS?
> If you want to make average-sized prints (up to 8x10 inches), 3–5 megapixels will be fine and give you a bit of leeway to do some minor cropping. For more options and larger outputs, more megapixels are needed to produce top-quality prints.

camera, and since as prices on digital cameras in general have continued to drop, some of these models are now priced under $1000—making them a real option for many photographers.

There are two types of digital SLRs: those with interchangeable lenses and those without. The ability to change lenses is a great asset, giving you the ultimate flexibility when creating your images—but DSLRs with this feature are also higher in cost. When buying such a model, note that the lowest price-point for any particular model usually includes the camera body only (no lens). If you own a film SLR, however, you may be able to purchase a DSLR that will allow you to use your existing lenses—which can save you a lot of money. If you are

buying your first SLR or buying one that won't work with your existing lenses, most manufacturers offer a package that includes the camera body and one lens at a very reasonable price. You can then continue to add additional lenses to your camera kit as your finances allow.

DLSRs normally feature an image sensor in the 6–10 megapixel range (but this is increasing rapidly). They also offer more advanced metering and focusing features than point-and-shoot models, and more flexible flash settings (although this is only occasionally an issue for landscape photographers, it may be an issue if you also use your camera to take family pictures, portraits, etc.). DSLRs also offer fully manual focusing, aperture, and shutter control—letting you take control of your images much more easily than with a point-and-shoot model.

If your budget allows it, a **DSLR** is a great choice for landscape photography.

OTHER FEATURES

On both point-and-shoot cameras and DSLRs, it's helpful to have a wide range of available ISO settings and a wide range of available shutter speeds (from very fast to very slow). Also, it's important to make sure that the camera is simply comfortable for you to work with. If you have large hands and a tiny camera with tiny buttons, you may find it quite frustrating to change settings quickly!

2. Lenses for Landscape Photography

FOCAL LENGTH

Lenses are differentiated by their focal length (or with zoom lenses, their range of focal lengths). Focal lengths are measured in millimeters, and range from wide angle (low numbers) to telephoto (high numbers). Midrange wide-angle to telephoto lenses are the most economical and work well for most types of images, including landscape photography. Extreme wide-angle and telephoto lenses can be very expensive (often thousands of dollars). These are fun to use if you have access to them, but you can certainly make great images without them.

FIXED VS. ZOOM

There are two basic types of lenses: fixed focal length and zoom. Fixed focal length lenses each provide one coverage area (you can't enlarge or reduce your view of a scene; it's fixed, as the name of the lens implies). Zoom lenses, on the other hand, let you "zoom" in and out to easily show more or less of a scene. Because of this, using a zoom lens gives you the most options when composing your landscape images. Even with DSLRs, which allow you to change lenses, using zooms let you avoid having to do so quite as often—meaning you can spend more time taking pictures and less time fiddling with your gear.

DIGITAL VS. OPTICAL ZOOM

On point-and-shoot digital cameras, you will often see two listings on the zoom lens. One is for the amount of optical zoom, the other is for the amount of digital zoom. The optical zoom is the number that you should pay attention to; it's the amount of enlargement that is possible using the superior optical qualities of the lens itself. The digital zoom, on the other hand, is actually just a non-lens function that enlarges your image using the camera's software. The

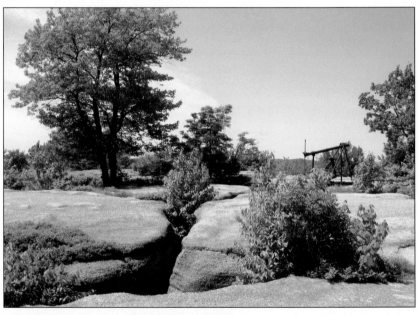

When you find a scene you like, be sure to take more than one shot. Start with an overall image using a wide-angle lens setting (above), then zoom in to capture the details of the scene (facing page left and right).

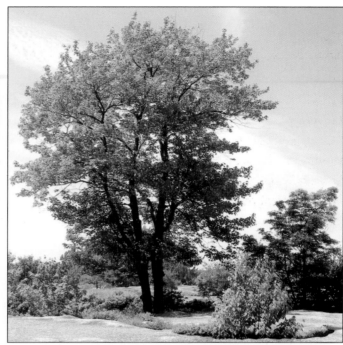

results this provides are usually not satisfactory. If you need to enlarge your image beyond what is possible with the optical zoom lens settings on your camera, it's better to do it yourself using your image-editing software (like Adobe Photoshop or Adobe Photoshop Elements).

ACCESSORY LENSES

For many point-and-shoot cameras, you can purchase accessory lenses that make your zoom more wide-angle or more telephoto. These lenses fit over the camera's existing lens (screwing on just like a filter). Before buying, take a few test shots with the lens to be sure you are happy with the results. It's not uncommon for these lenses to produce a little distortion—especially near the edges of the frame.

LENS CONVERSION FOR DSLR CAMERAS

When using a DSLR, the effective focal length of your lenses may be different than when using them on a film SLR. This is because the effective focal length of a lens is related to the size of the film frame or digital sensor that is recording the image. On many DSLRs, the image sensor is smaller than a 35mm film frame, so lenses used with these cameras all become, effectively, somewhat longer (more telephoto). Check your camera's manual for information on this.

Although this effect can make telephotos more powerful, it also makes wide-angle lenses less wide-angle—which can be an issue in landscape photography, where very wide-angle lenses are commonly used to great effect.

Accessory lenses add function to the zoom on your point-and-shoot camera.

3. Using Filters

WHAT THEY ARE

Filters are pieces of glass or gel material that are used in front of the camera's lens. These block certain wavelengths of light (enhancing contrast in black & white images), add special effects, reduce haze and glare, or adjust the color rendered in a scene.

TYPES AND SIZES

Filters come in many different types and sizes. Before buying, read your camera's manual to determine whether filters can be used with your camera or lens.

On DSLRs with interchangeable lenses, each lens may take a different size filter. Step-down and step-up rings, however, can be used to make filters fit more than one lens. If you're not sure what you need, take a trip to your

> ### WHITE BALANCE
>
> When using a colored filter, be sure to set the white balance on your camera to something other than auto. In the auto mode, the camera's built-in software will work to neutralize the color of the filter, thereby eliminating its effect.

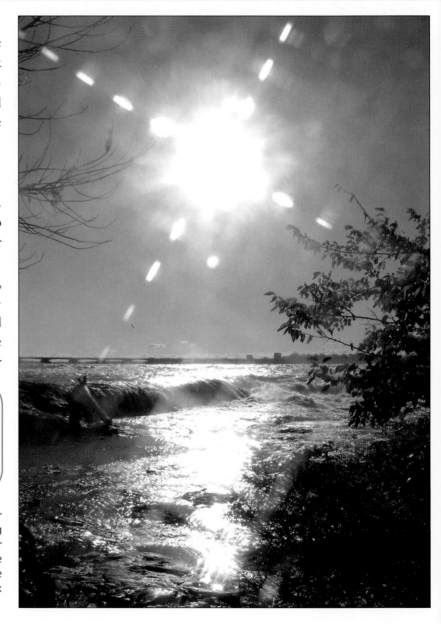

A star filter turns any very bright highlights in your image (here, the sun) into starbursts of light. Depending on the filter you choose, you can create four-, six-, or eight-point stars. Star filters can also be rotated on the front of the camera to turn the rays of light to just the right angle for your composition. It's not the right look for every image but can add a little flair to select shots.

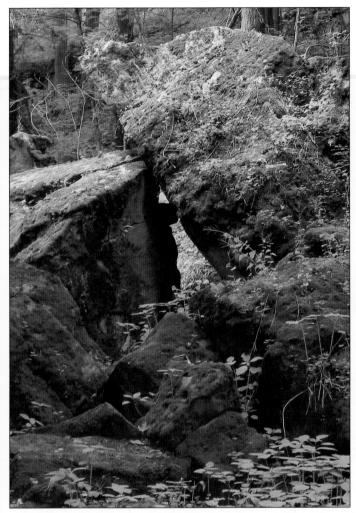

Diffusion filters are used to add a delicate glow to images. Don't confuse this with poor focus. Diffused images are still correctly focused, they just have a more radiant look in the highlights.

local camera store and bring your lenses along with you.

Point-and-shoot cameras with a zoom lens usually require an accessory in order to use filters. This tube-like device threads onto the front of the camera and encases the lens (allowing it to zoom in and out). At the end of the tube are additional threads that allow you to screw on a filter in front of the lens.

EXPERIMENT

The best way to learn about filters is to experiment with them. Try them out with different scenes, under different lighting conditions, and at different camera settings.

On the facing page, you'll see the effect that some commonly used filters can have on a scene. But don't limit yourself to just these—try a variety of filters to enhance your work!

4. Tripods (and Other Camera Supports)

Tripods, monopods, and other camera supports are used to stabilize your camera while taking pictures. This comes in handy when you want to take a long exposure (like for a night photo [see lesson 29] or to blur water [see lesson 39]). However, a tripod can also be a useful creative tool, since it forces you to slow down and really examine the scene in front of you before you snap a photo. This gives you time to carefully compose the scene, look for distractions and other problems, and decide if anything needs to be adjusted to create the best possible image.

TRIPODS

Tripods are three-legged camera supports. Before investing in one, make sure your camera has a mount for one on the bottom (a small hole with threads to accommodate a screw). When shopping for a tripod, make sure the model you buy is sturdy. Tripods take a lot of abuse—being used in wet and dirty conditions, thrown in trunks, etc. You should also make sure the tripod is tall enough for you to work at comfortably but offers enough variation in height settings to allow you to shoot lower if you want. You should also make sure that the head (the part where you attach your camera) moves easily, so you can adjust it without a struggle.

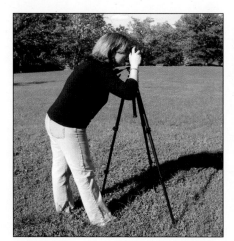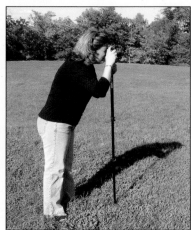

MONOPODS

Monopods are camera supports that only have one leg. They usually have a small spike on the bottom so you can dig the tip into the ground to stabilize it. Monopods don't offer as much stability as a tripod, but they easily double as a walking stick, making them more convenient for hiking.

OTHER SUPPORTS

In many situations, you can find natural camera supports on site—the roof of a car works well, as does a large rock, a stone fence, a fallen tree trunk, etc.—you can even place your camera on the ground!

Using a tripod (left) or monopod (right) stabilizes your camera and gives you more time to think about your image. Standing with your feet at about shoulder width provides greater stability whether you are handholding the camera or shooting with it on a support.

FACING PAGE—Creating a blurred look on moving water requires long shutter speeds (long exposure times). Unless the camera is kept still during the exposure, however, the whole image will end up blurred—not just the water.

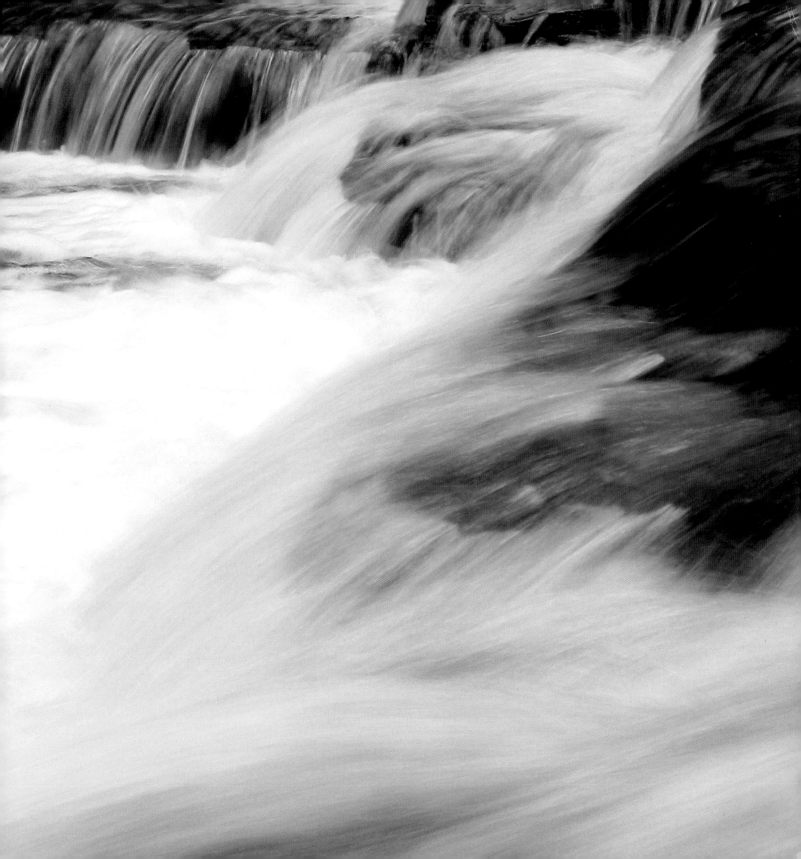

5. Sky, Water, and Land

In landscape photography, we don't have to worry about props, people's expressions, posing, etc. Instead, the "ingredients" with which we make our photos are a bit more simple. The most basic of these are sky, water, and land. In almost every landscape image you take, at least one of these ingredients is likely to play an important role.

SKY

From golden dawn, to azure blue, to rosy sunsets, the sky looks best when it has some color. If at all possible, avoid shooting on days when

the sky is a solid white mass of textureless clouds (or, on these days, avoid including the sky in your images). Plain white skies are boring and create a "bald" area at the top of your photograph.

RIGHT—When photographing water, it's motion, sparkle, translucence, and reflections that make the subject look its best.

BELOW—When it's alive with color, the sky alone can be your subject.

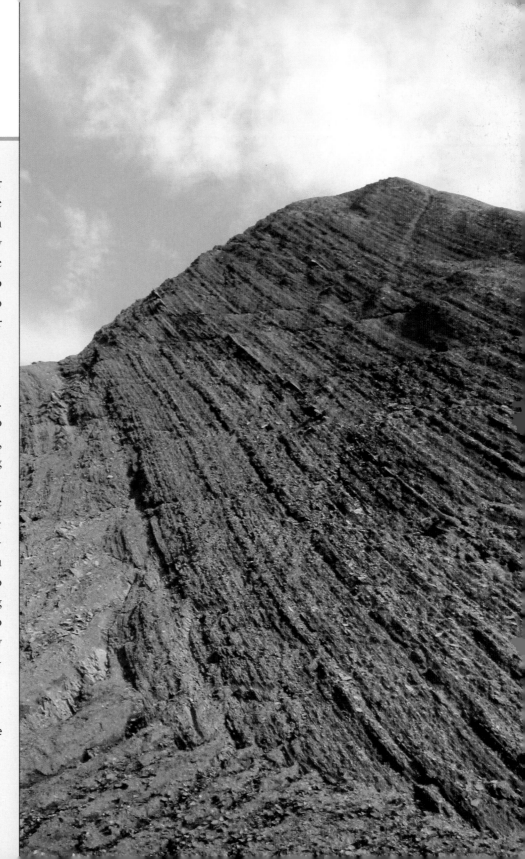

WATER

Whether it is trickling, gushing, falling, or crashing onto the shore, water is one of the most popular landscape subjects around. When photographing water, look for ways to show reflections, sparkles, and translucence—the characteristics that make water so magical. To show the motion of water, you simply need to select a long shutter speed (see lesson 39 for more on this).

LAND

By itself, the land can create dazzling images. From the foreboding look of jagged cliffs to the tranquility and vastness of rolling plains, the land itself displays many visually compelling characteristics.

It's the shadows that shape the look of the land, giving it the appearance of depth and texture in a two-dimensional photograph. If possible, therefore, you may want to visit a site you plan to photograph at different times of day to determine when the light on it seems to bring out the qualities of the land that you want to capture in your photographs. For tips on how light changes over the course of the day, see lessons 25–27.

When photographing the land (right), shadows reveal the texture and shape of the subject.

6. Trees, Plants, Rocks, and Clouds

Trees, plants, rocks, and clouds can be interesting subjects in and of themselves, or simply used as "props" to enhance the message you want to communicate.

TREES

Trees are one of the most common landscape photo elements. How, then, do we make them stand out in *our* images? The answer is composition—how we arrange them in our frame. This will be covered in more detail later, but for now, consider these tips:

1. Use trees (or openings in branches) to frame a second subject.
2. Make a single tree huge (so it takes up the whole frame), or make it very small (so it is isolated in a vast background).
3. Look for ways to show patterns (a row of very straight trunks or a series of nearly identical trees) or individuality (one maple tree on a hill of pines).

PLANTS

Plants can be used to fill the foreground (the area close to the camera) in wide-angle landscape shots and are also good subjects on their own. Look for ways to show patterns (like a whole field of daffodils) and textures (like a single leaf filling the whole frame).

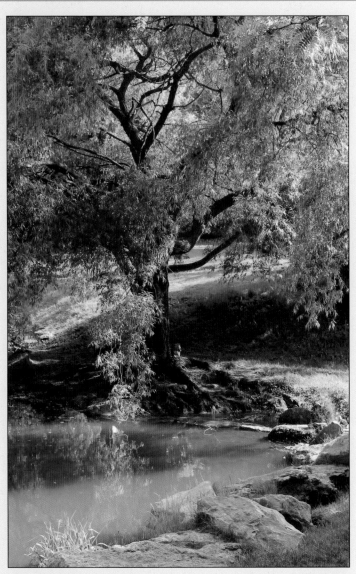

Here, the rocks, grass, and water in the foreground serve as supporting elements that draw your eye to the tree.

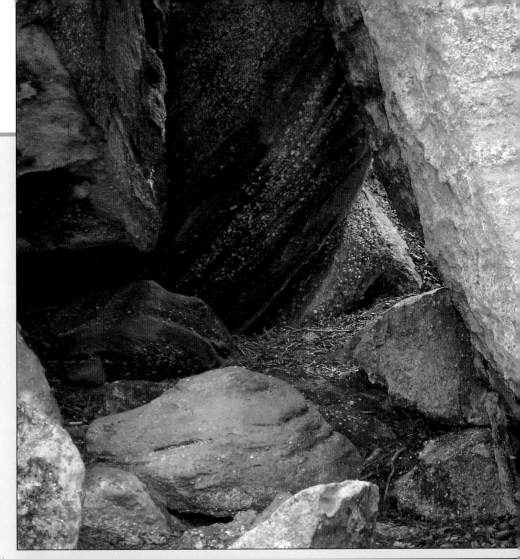

Since plants tend to be low to the ground, try shooting from an equally low camera position. This creates a more interesting image because it presents the scene in a different way than most casual viewers would see it.

ROCKS

Rocks, like plants, can be good foreground fillers or subjects for "texture" images. Look for wet rocks (or wet them yourself) to add sparkle and, in some cases, enhanced color. Check your exposure carefully (see lessons 18–21), since dark-toned rocks can sometimes lose shadow detail.

CLOUDS

When taking pictures of clouds, look for color and texture. Fluffy clouds in a bright blue sky, streaky clouds turned red and orange at sunset, and menacing storm clouds are all good subjects. Contrails, the streaks left by jets as they cross the sky, can also be interesting subjects. Check the exposure; bright white clouds can trick your camera's light meter.

TOP—Finding low-contrast lighting helped to retain as much detail as possible on these glacial rocks.

BOTTOM—Getting down to flower height and shooting into the deep bed created an image that is more about the patterns of the flowers than one individual bloom.

7. Patterns and Textures

Many landscape photographers get caught up in the majesty of massive subjects and overlook the more simple beauty of the patterns and textures that exist in scenes they see every day. Don't fall into this trap! Keep your eyes open for the interesting patterns and textures that add depth and detail to the world around us.

When photographing textures and patterns, composition is extremely important (see lessons 9–17). That's because what makes this type of photograph interesting is not so much the subject itself, but the shapes the subject (or subjects) creates within the frame.

Pattern and texture images can run the range from very wide views (like the field of pumpkins to the right) to very closeup views (like the leaf on the facing page).

When shooting wide-angle images, pay special attention to the edges of the frame as you compose your image. When there's so much to look at in your viewfinder or on your LCD screen, it's easy to miss distractions at the far edges of the frame. It's definitely no fun to get home with your new images only to discover that there's a tree branch sticking into the side of every shot.

When shooting close-up images, focus is critical. If your camera has one, this is the time to use the close-focusing setting (usually indicated by a flower icon on the camera). You may also want to use a tripod or camera support, since camera shake becomes more pronounced with closer subjects. After shooting, check your image on the camera's LCD screen to ensure the focus is good.

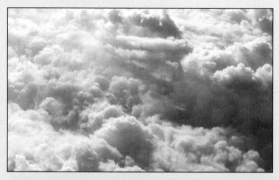

Clouds, here shot from a commercial airplane, create beautiful patterns.

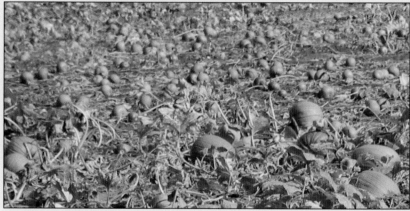

ABOVE—This field of pumpkins was photographed in the early fall. The pattern of green leaves and orange pumpkins was shot from a slightly elevated camera position, looking down across the field.

FACING PAGE—This closeup image of a leaf was photographed just after a rain storm when the bright sun suddenly reappeared and made the drops on the leaf sparkle. You could get the same effect in a freshly-watered garden.

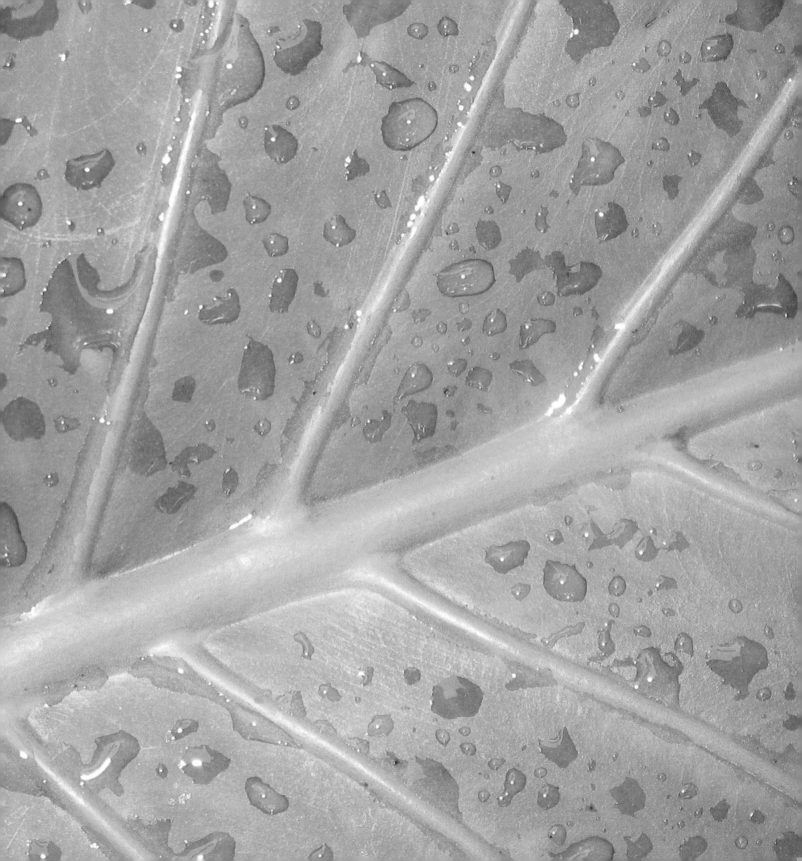

8. People and Man-Made Objects

SCENE STEALERS

Most landscape photographers tend to avoid including people or signs of human habitation in their images. Why is this? It's simple—people and their constructions almost always steal the show. They attract our attention in a way that most landscape elements just can't compete with.

That said, nonprofessional photographers (people who don't spend days or weeks at a time traveling to different locations and scouting images) often have trouble finding "unspoiled" subjects for their images. After all, for most of us, the most desirable subjects we have access to are in parks, gardens, nature preserves, and other areas where fences, signs, picnic tables, trash cans, litter, cars, and people are simply a fact of life.

There are a few easy solutions to this very common problem.

COMPOSE CREATIVELY

One strategy is to look beyond the obvious ways to photograph a scene. Look for ways to get up high enough to shoot over fences and signs. If you have a pickup truck, try shooting while standing in the bed. Many professional photographers pack low stepladders for just such occasions. Try getting down low and shooting under fences. Look for details of the

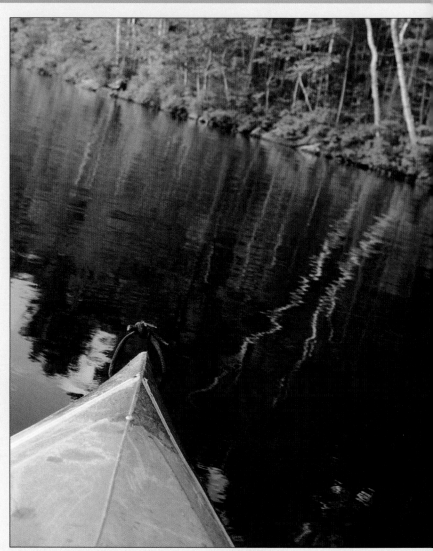

Man-made objects can steal the viewer's attention from the landscape. For some images, works just fine. Here, with the camera tilted significantly, the shoreline, the light tree tru (and their reflections), and the lines of the kayak all form strong diagonal lines. Including kayak gives the viewer a sense of seeing the scene from the water.

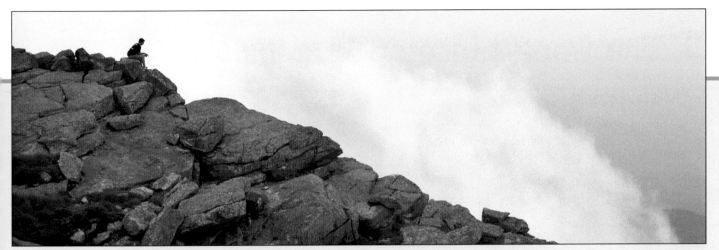

This rocky slope at the 4,000 foot summit of Whiteface Mountain in the Adirondacks region of upstate New York is a strong subject—especially with the misty clouds creeping up behind it. The subject seated on the top steals the scene, though.

scene that you can photograph while eliminating man-made objects from your images.

WORK WITH THEM

If you can't work around people and man-made objects, your other choice is to work with them. Find interesting ways to include them in your image while working to keep the viewer's primary focus on the landscape. For example, you can use these readily-identifiable objects (like a winding road) to communicate a sense of the scale of the scene.

USE DIGITAL IMAGING

Finally, if you can't avoid these distractions and you can't make them work to your advantage, consider using digital imaging software to remove them. This works well with small objects (like litter and signposts) and can rescue an otherwise unusable image.

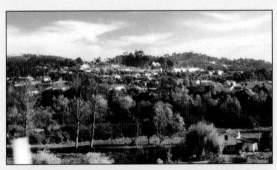

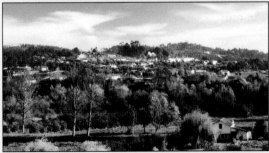

The top photo was taken from a speeding passenger train in Portugal. At 85 miles per hour, there's no time to carefully frame the shot! The blurry white signpost near the left edge of the frame was, however, easily removed in Adobe Photoshop Elements (bottom photo).

9. The Importance of Composition

Composition is the term used to describe the conscious placement of subjects within the frame.

Believe it or not, more than any other factor, composition can make or break a photograph. This is especially true in landscape photography, where we don't have facial expressions, clothing, or props to keep the viewer interested in our images.

Because our frames are filled with things that, on their own, might not be all that exciting (rocks, water, trees, etc.), we must rely on the way we present them—the way we compose them—to attract and retain our viewers' attention.

Let's start off with what *not* to do.

CENTERING

The most boring composition you can use is one where you simply center your subject in the frame. This "bull's-eye" type of composition is very static and doesn't encourage the viewer's eyes to linger and roam around the frame. Their gaze hits the center of the image, identifies the subject, and is then ready to move on to the next image! Placing your subject off center instead (see lesson 10) makes the viewer's eyes travel around the image, evaluating the main subject and the areas around it—which is just the reaction you want!

The only time you might want to center something in the frame is if you are trying to show symmetry—say a single, perfectly symmetrical tree or a single snowflake.

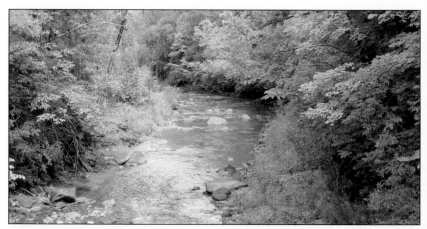

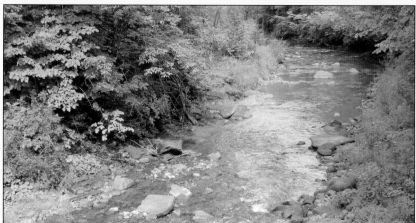

Centering your subject (top) almost always produces a boring image—especially when the scene has a natural sense of direction. In the bottom image, the subject (the bend in the creek) is placed near the edge of the frame, letting the water "flow" down and across the frame.

AVOID DISTRACTIONS

The next thing to avoid are some common distractions. We've already addressed the fact that people and man-made objects can be scene stealers, but there are other elements that can distract viewers.

Our eyes are drawn to areas of contrast in a frame. Imagine you have photographed a scene of rolling green hills. Now imagine that there is one tree on one hill with leaves that have turned red. Where are your eyes going to be drawn in that photograph? Right—directly to that one red tree. If you've composed the image intentionally to show the contrast of that tree with the surrounding ones, this can be a great thing. If you really wanted to show the shape and texture of the rolling hills and didn't even notice the red tree until you got home, it can be very disappointing.

Another problem that everyone has sooner or later is that we all tend to get wrapped up with what's at the center of our frame and therefore miss seeing distractions at the edges. A common one in landscape photography is a branch (or some other piece of foliage) sticking into the edge of the image. It's easy to miss when shooting, but you'll notice it instantly when you get home and review your images! Therefore, make it a habit to check the edges of the frame before you shoot each image.

In the image on the left, the bridge is a serious distraction—especially since the line of the shore leads your eyes directly to it! In the image on the right, simply adjusting the camera's position resulted in the bridge being concealed by overhanging branches.

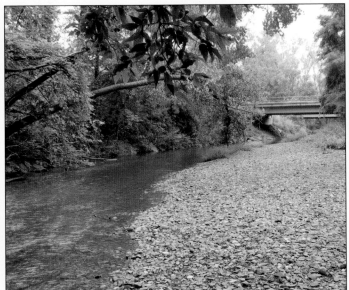
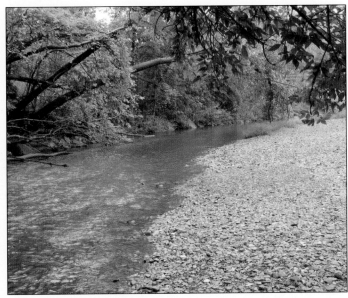

10. The Rule of Thirds and the Golden Mean

The rule of thirds and the golden mean are formulas photographers and other artists use as a guideline for determining a strong place to position their subject. Note that these are not hard-and-fast rules. Your subject and aesthetic sensibilities will ultimately determine the best composition for each image, but these ideas provide a good place to start and will help you remember to avoid centering the subject.

THE RULE OF THIRDS

According to the rule of thirds, the image frame is divided into thirds (like a tic-tac-toe board). This is shown in the diagram to the right and the image below it. Subjects can be

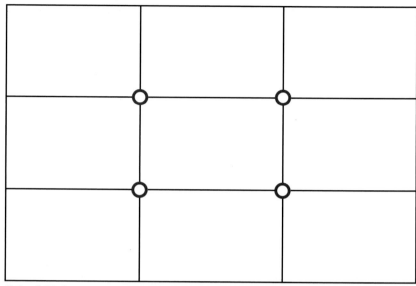

Rule of thirds.

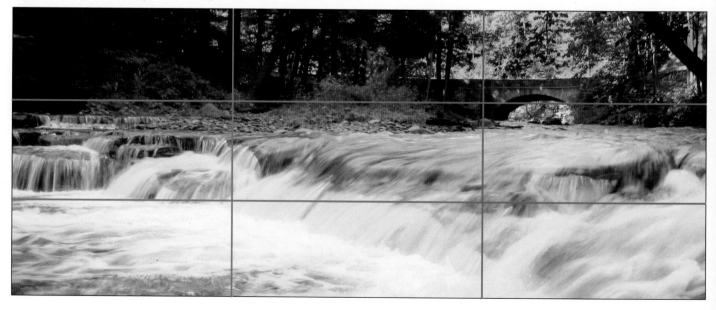

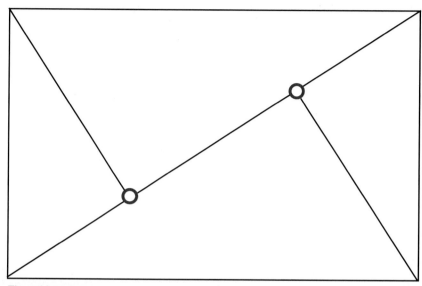

The golden mean.

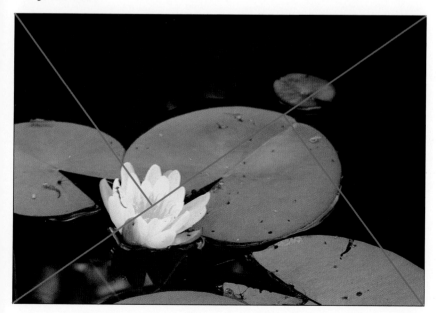

successfully placed along any of these lines and are further emphasized by placing them at the intersection of any two lines (these intersections are sometimes called "power points").

THE GOLDEN MEAN

To determine subject placement according to the golden mean, draw a diagonal line from one corner of the frame to the opposite corner. From each remaining corner, draw a diagonal line that intersects the first line at a 90-degree angle. The points where these lines intersect (as shown in the diagram and the image to the left) are considered strong points at which to place a subject. Note that these points are very similar to those determined by the rule of thirds.

FRAME SIZE AND ORIENTATION

Whether your image is horizontal or vertical, each of these guidelines apply in exactly the same way. They also apply to any shape of frame—from square to panoramic.

CROPPING

When using image-editing software to crop your images, you should keep these guidelines in mind. Cropping can change the composition of your image by altering the visual relationships between the elements in the frame.

11. The Horizon and Shorelines

A common element in many landscape images is the horizon line. Because this line runs the entire width of the frame, it is a powerful compositional element and needs to be considered carefully to create a successful image.

PLACING THE HORIZON

In most cases, you should avoid having the horizon line fall in the middle of the frame. Centering the horizon (from top to bottom) divides the image into two equal halves. When this is done, it becomes unclear to the viewer what the intended subject of the photo actually is. Is it the lake in the bottom half of the frame or the cloudy sky in the top half? Much like centering your main subject in the frame (see lesson 9), centering the horizon often creates a static and unappealing image.

Instead, the horizon should be placed higher or lower than the center of the frame—often along one of the horizontal lines in the rule-of-thirds grid (see lesson 10). Positioning the horizon in this way divides the image into a large section and a small section, creating visual tension that is more compelling to view. By virtue of its greater size, the larger area of the image will also become more prominent, ensuring that the intended subject of your image is the one that viewers' eyes are most naturally drawn to.

Centering the horizon in the frame creates a static composition. Because they are equal in size, it's not clear if this image is about the top half of the frame or the bottom half.

Placing the horizon higher or lower (often along a rule-of-thirds line) makes the subject of the photograph more clear and improves the composition.

Horizons, shorelines, etc. should all be horizontal (bottom). Tilted lines (top) can seem very unsettling and unnatural.

KEEPING IT STRAIGHT

One hallmark of sloppy composition is a tilted horizon line. It's easy to get caught up in composing the other elements of your scene and fail to notice that your camera is slightly tilted—but you'll notice it when you get home! When we look at a scene, the horizon is—well, *horizontal*, and so it should be in our images.

Normally, straightening the horizon should be an easy task—just level the camera. When shooting receding elements, though—say, a line of trees that is closer to the camera at the left edge of the frame than at the right—it can be a bit more tricky, since the subjects themselves create a diagonal line that can be disorienting. Take your time and consider your composition carefully before shooting.

Successful images can also be created by intentionally tilting the horizon. The key to success with this type of composition is to use so dramatic a tilt that it is clearly intentional.

SHORELINES

The same rules that apply to horizons also apply to shorelines. The exception is when you are showing an object and its reflection in the water; in that case, centering the line between the reflection and the actual object helps to make it clear that the two elements are to be considered jointly and are intrinsically related.

12. Framing and the Foreground

FOREGROUND

For the most part, the subjects we work with in landscape photography are quite far away from us. Because of this, there is often a foreground area (the area between the camera and the subject) included within the frame. If this area is not used constructively, it can sometimes look like a big, boring void sitting at the bottom of the photograph.

The best way to eliminate this problem is to look for interesting elements to place in the foreground. In addition to giving the frame a sense of completion, these elements can help you to communicate the scale and depth of the primary scene that is shown beyond them.

FRAMING

One way to create an especially interesting composition is to use framing elements in the foreground. When you look at an image that employs framing elements, your gaze seems to travel back into the image—creating a good sense of depth. Framing is as simple as finding elements in your scene that can be used to attractively fill all of the edges of the frame. In the image on the facing page, the mouth of a

Without the snowbanks in the foreground, the bottom of this image would be a flat expanse of snow. Incorporating this foreground element simply required working from a very low camera angle (about 18–24 inches off the ground).

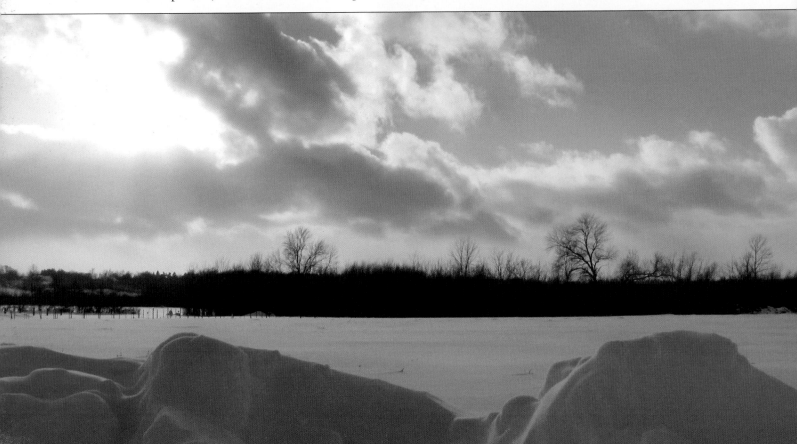

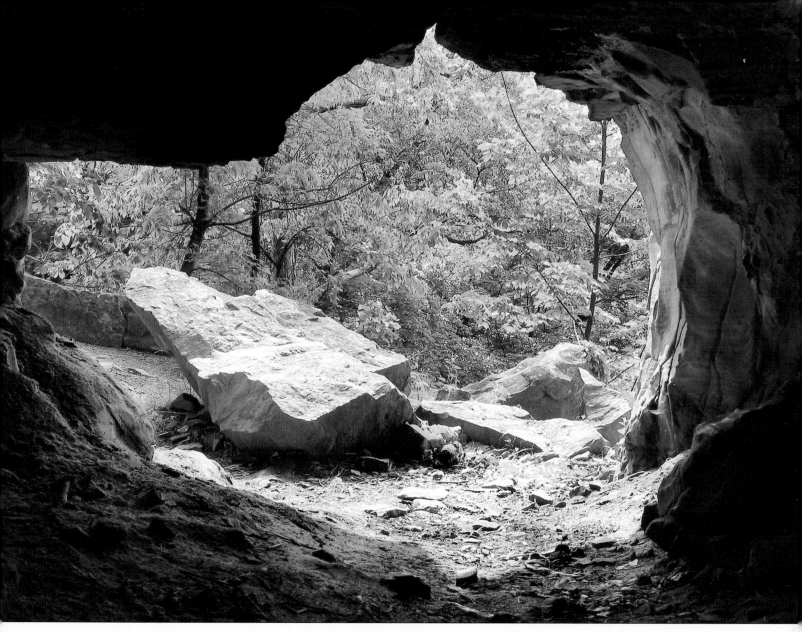

Here, the mouth of a cave frames the trees and rocks outside.

cave was used, but you can also use trees, grasses, mountains, or just about anything else.

FOCUS

When including foreground elements in your compositions, be sure to use sufficient depth of field (see lesson 23) so that these elements are in at least reasonably good focus. Foreground elements that are very blurry can be more distracting than enhancing—actually drawing attention away from the main subject of the photograph.

13. Lines

Lines (whether they are actual, like the line of the horizon, or implied, like the course of a stream) are present in almost all of our images. How we use them can make a big difference. An important thing to keep in mind is that the lines in your image should be used to draw the viewer's eye *into* the image; they should not lead it *out* of the image. So check the lines carefully to make sure they all direct your gaze back toward the subject(s).

CURVES

S-curves can be effective in composing an image. In the image to the right (top), the road leading out to the hills has an S-curve that leads your eye through the frame. You can also find S-curves in crooked trees, the paths of wandering streams, and much more. C-curves can also be found in nature and used as the basis of interesting compositions.

LEADING LINES

Lines used to draw your eye into the frame and toward the subject are called leading lines. These can be fences, the trunk of a fallen tree,

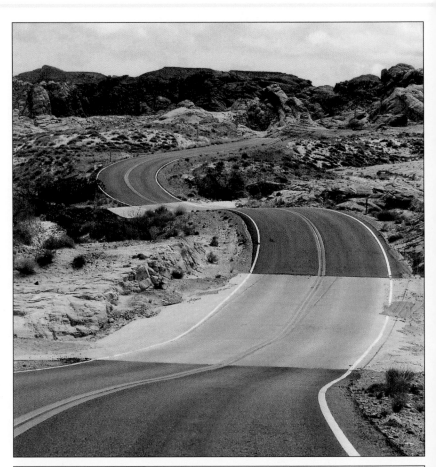

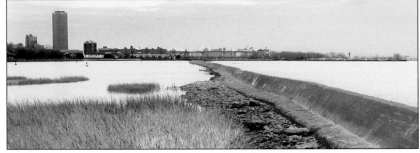

TOP—In Nevada's Valley of Fire State Park, a curvy road fills the foreground and winds back into the image, taking your eye with it. BOTTOM—In this image, the cement breakwater leads your eye diagonally from the marshlands and water in the foreground to the cityscape in the background.

the course of a stream—the list is just about endless!

CONVERGING LINES

Lines that converge, like the train tracks in the image to the left, help draw the viewer's gaze back into the frame and show the depth of the scene being presented.

HORIZONTAL AND VERTICAL LINES

When horizontal or vertical lines are included in your image, they should be completely horizontal or vertical and not tilt off slightly to one side. This is the way we see the world with our eyes, and making it look otherwise in your images can create an unsettling effect.

DIAGONAL LINES

Diagonal lines are usually more interesting to look at than perpendicular or horizontal ones. If a scene seems a little dull because it is too rectilinear, consider tilting the camera. When you do so, the vertical and horizontal lines will instantly become diagonals. Be sure to tilt the camera far enough that it looks intentional—not like you just set up your tripod wrong.

In this image, the converging lines of these abandoned train tracks lead your eyes back into the image. Their centered composition emphasizes their symmetry in contrast with the overgrown foliage around them.

14. Textures, Patterns, and Repetition

TEXTURES

Textures can include small-scale subjects (like tree bark) or large-scale ones (like the surface of a choppy sea). These images need to be composed carefully to be successful. Look for lines and shapes within the details of the texture and incorporate these in your image. For rough surfaces, harsh, directional light that produces dark shadows may work well. For smooth or delicate textures, softer light may be more appropriate and render the texture more gently.

PATTERNS

Considering how chaotic nature can sometimes seem, it's really quite amazing the number of patterns that seem to occur—if you're looking for them. Look for wear patterns where water flows across rocks. Look for a row of trees that constant wind has made lean in one direction. Examples abound—but you do have to keep your eyes open!

REPETITION

Repeating subjects can create really compelling images. The key to composing them is to look for ways to make the subjects look as uniform as possible. If you have a choice, compose the image to exclude anything that is different in color, shape, or texture.

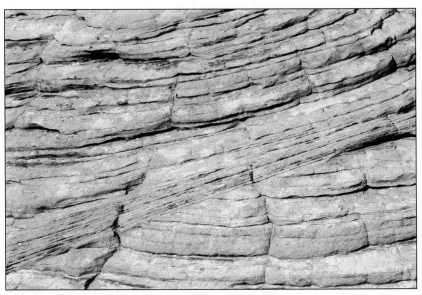

Over the course of thousands of years, erosion can create beautiful patterns in rocks. Here, a grid pattern is intersected by a sweeping diagonal line.

HEED ALL WARNINGS

The desire to get that perfect image can sometimes overwhelm even the most cautious photographer's better judgment. When it does, the result can be prosecution by an angry property owner—or worse. Warning signs are in place for a reason, so pay attention to them. Your safety is much more important than any image.

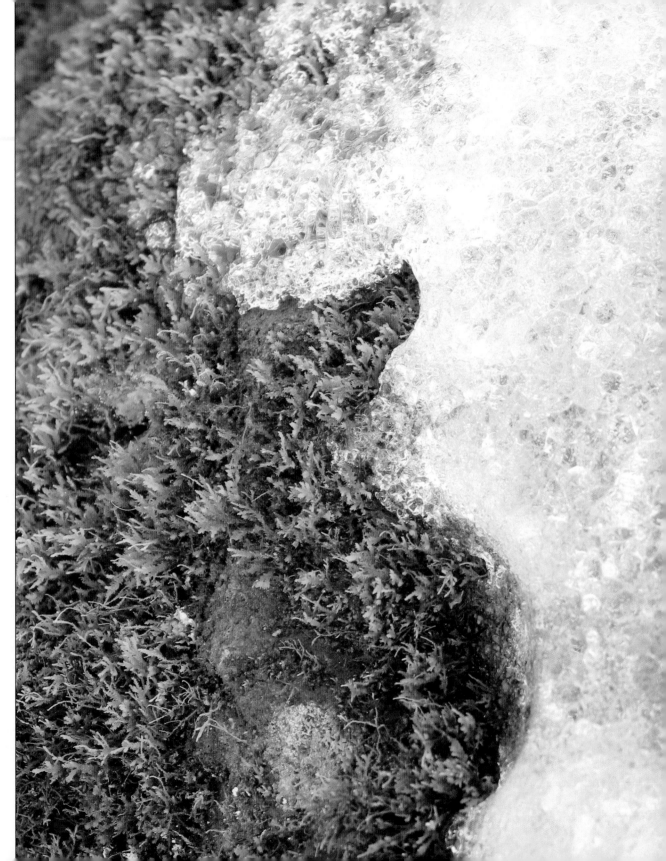

Shot on a warm day in February, the moss and the ice were fighting for control of this rock at the edge of a stream. The contrast between the two (in terms of their color and texture) as well as their seasonal nature makes a nice image. The curving diagonal line where the two subjects meet is a strong compositional element in this image. Notice, also, that the shallow depth of field (see lesson 23) causes the areas receding from the camera to go out of focus, revealing the roundness of the rock.

15. Visual Weight, Tension and Balance

Every single thing you place within your photographic frame has its own visual weight—the amount of attention your eyes will naturally give it. There are several factors to consider.

1. Warm colors (red, orange, yellow) advance and attract attention. Cool colors (blue, green) recede, attracting less attention.
2. Bright elements generally attract more attention than dark elements. The exception is when the scene is almost all light, in which case dark elements will attract attention. This is because our eyes are attracted to areas of contrast.
3. Size also plays a role. Among the shapes in an image, our eyes are first drawn to the biggest ones. If the image is interesting enough that we continue to look at it, we will eventually start to examine the smaller elements and details. Note that "size" here has nothing to do with how big something actually is in real life. If you took a close-up

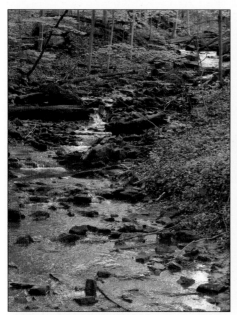
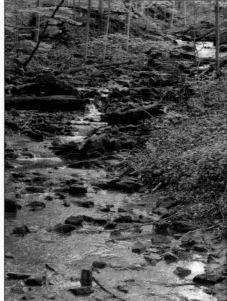
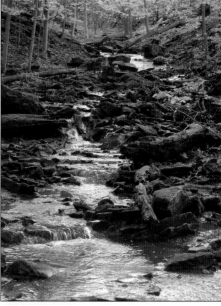

Of course there wasn't a big red spot in the original scene, but imagine it was a brightly colored flower. Where do your eyes go in this frame? They probably bounce between the "flower," which by virtue of its warm color advances among the cool tones, and the bright spot at the upper right corner.

Here's the same exact image without the red "flower." The focus is now more clearly on the stream. Now, the points you probably see first are the three bright areas (top right, middle left, and bottom right). Again, it's better—but the composition is still disjointed.

Stepping a little bit to the left and zooming in on the scene totally changed the way the sun through the trees reflected on the water. The way the highlights fall now lets the viewer more readily track the course of the water as it flows through the frame from top to bottom.

Stepping even closer and framing the image as a horizontal provided a still better viewpoint. Now the water is definitely the subject. The huge rocks and fallen tree trunks around it are now big enough that, sheerly by virtue of their size, they become supporting elements in the composition. This makes sense, since it was these elements that really made the stream look special. Notice how the lines of each of these large elements point back toward the stream—an effective way to use lines in a frame. Making the little waterfalls more prominent also gives you a better idea of the slope of the stream.

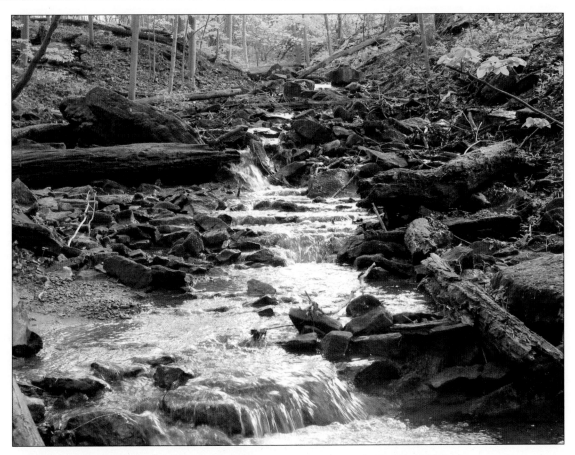

shot of a ladybug on the trunk of a giant redwood tree, the ladybug would be the big element. The tree, represented by the texture of the bark would be, visually, the smaller, detail element.

4. Curved and diagonal lines, as discussed in lesson 13, also attract more attention than straight lines.

TENSION AND BALANCE

With an understanding of visual weight, you can begin to create tension and balance in your images. Tension is a sense of contrast (a bright-red flower in the very corner of a frame otherwise filled with green grass); balance is a sense of equilibrium (a large, dark tree and sky with a small, bright moon).

16. Symmetry and Visual Movement

SYMMETRY

As discussed previously, centered compositions are normally one of the weakest, least visually stimulating ways to present your subjects.

One exception to this rule is when you want to emphasize the symmetry of a single subject. In that case, centering it works well. With symmetrical subjects, the balanced space on either side of the frame causes the eye to continually move back to the center of the frame, the point at which the subject is mirrored.

The other exception is when a subject is reflected. Then, centering the horizon or shoreline will help to communicate this clearly.

VISUAL MOVEMENT

For just about every other subject, your goal should be to create a sense of visual movement—an arrangement of subjects that encourages the viewer's eyes to move across and around the image.

As discussed in the previous lesson, different elements in your image have different visual weights. Creating a sense of visual movement in your image requires you to use that knowledge to your advantage.

The place where you want your viewer's eyes to be drawn first when they look at your image should be given the greatest visual weight. It can be bigger or brighter than the

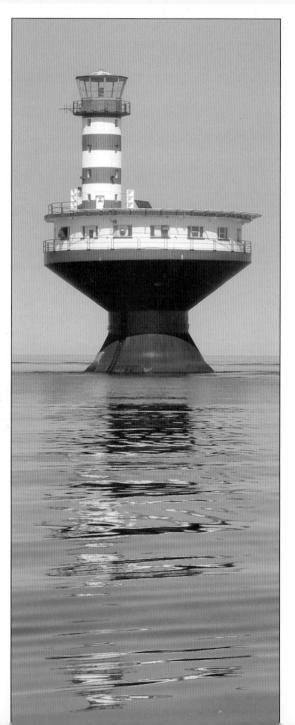

Centered compositions can be effective when showing the symmetry of a subject. Here, a lighthouse on the St. Lawrence River is basically mirrored left to right (the left side of the image is close to a mirror image of the right side of the image). Through its reflection, it's also mirrored from top to bottom.

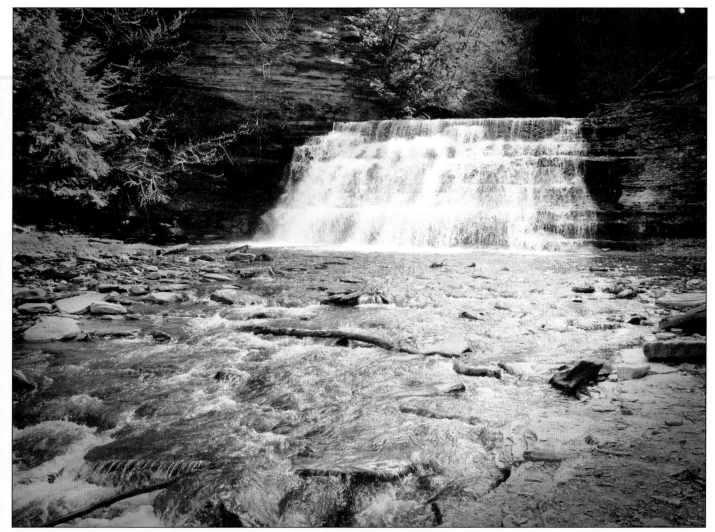

To create a sense of visual movement, this waterfall was composed near the edge of the frame, giving the water room to flow down through the image—drawing your eye along with it. Notice that the waterfall is placed according to the rule of thirds (see lesson 10). Because there were still some distractingly bright areas at the edges of the frame, a vignette (darkening at the edges) was added to the image (see lesson 47).

other elements in the frame, it can be the only crooked or diagonal line in a sea of straight vertical lines, etc. You can also emphasize the subject's natural visual weight by placing it at a "power point" in the image (see lesson 10).

To draw the viewer's eyes on to secondary subjects in the image, try using leading lines (see lesson 13) or place the subjects at another of the "power points" in the composition.

17. Camera Angle

You might be thinking, "Well, all that stuff about leading lines and visual balance is great—but where do I find scenes that just happen to have all that in just the right place for me to photograph it?" The answer is that, most often you *won't* just stumble upon the perfect scene. It's what they do with *imperfect* scenes that sets professional photographers apart from amateurs. After all, given that we all live on the same planet, we all have pretty much the same stuff to work with.

Consider Ansel Adams—probably the most acclaimed landscape photographer in history. Think of how many people visit Yosemite National Park in a year. Now, think about how many of them consistently create images that rival Adams' stunning renditions of this park. He had a singular ability to see the same old rocks and trees in a magical way.

Given that you can't, for the most part, refine or adjust the scene you see before you, manipulating the composition of the scene means changing the one thing you are in control of: you. Believe it or not, it's that simple.

But, of course, it's also *that hard*. Really looking at a scene, trying out different camera

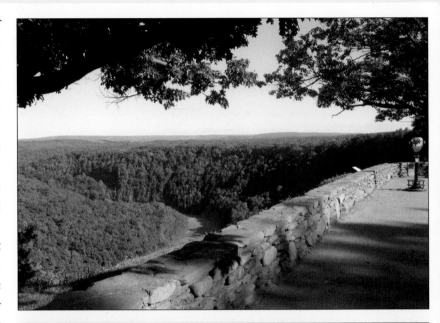

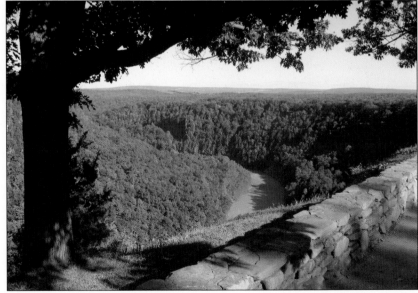

In the first image (top), the branches and other elements clutter the scenic vista. By stepping a few feet to the left, the tree and rock wall are composed to frame the valley scene rather than fight with it for attention (bottom).

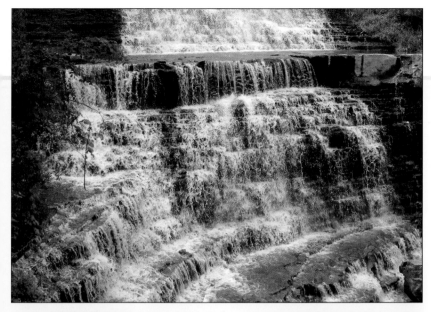

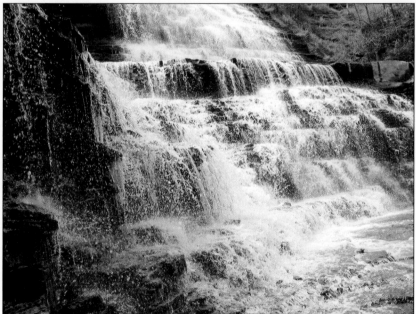

The easy shot (top) was the waterfall from above at the edge of the gorge. The better one (bottom) was taken after a five-minute crawl down a rocky slope to water level. Both images show just about the same part of the waterfall, but the perspective makes a big difference in the look of the overall composition.

positions and compositions . . . well, it takes some time. You probably won't hit upon the best composition in the five to ten seconds most amateur photographers spend composing their images. Imagine how much better your images could be if you took five or ten *minutes* to compose each one. Now, imagine what would happen if you took an hour. Believe it or not, professionals often spend days getting just *one* perfect image!

Now, for most casual photographers, that's simply not an option. Most of us take our landscape images while out on a hike with the kids, while pulled over at a scenic overlook to check out the view and grab a sandwich from the cooler, etc. Even given these constraints, however, taking a few minutes to try out some compositional variations can make a big difference. Try taking a few steps to the left or right. Try shooting from down low or up high. If you are using a zoom lens, zoom in and out to find the best way to present the scene.

Best of all, since you are shooting with a digital camera, you can actually photograph *all* of these attempts without having to pay a cent to develop them. Later, when you get home and the kids are in bed, you can upload your photos and sort them out to determine which one is the best of the bunch. If you're lucky, you'll love a few of them!

18. Digital vs. Film

If you're accustomed to shooting negative (print) film, you'll need to adjust your normal exposure techniques somewhat as you make the leap to digital.

With negative film, the usual exposure strategy is to meter and expose for the shadows, ensuring that you will get detail in the darkest area of your image. Negative film is great at holding detail in bright highlights, so these areas become a secondary consideration when exposing. Negative film also has a high exposure latitude, meaning that the exposure you (or your camera) selects can be significantly off from the "perfect" exposure for the scene and still yield a usable negative.

With digital, the story is a little bit different. Shooting digitally, as far as exposure is concerned, is more like shooting slide film. Instead of exposing and metering for the shadows, you expose and meter for the highlights. Also, your exposure must be more precise to produce a usable image—one with printable detail in both

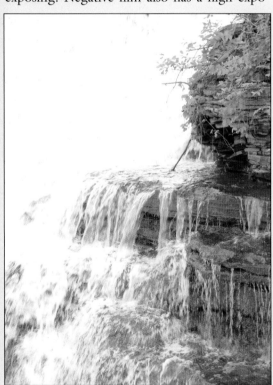

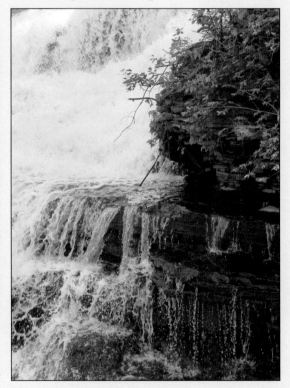

For the image on the left, the exposure was metered off a dark area on the rocks. This rendered the stones well, but the waterfall is so lacking in detail that it's almost impossible to even identify. On the right, the exposure was metered off the water, producing an exposure that better retained detail in this area. The rocks may be a little dark (depending on your tastes), but they could be lightened easily using Adobe Elements, whereas it would be impossible to restore the lost detail on the water. (If you were feeling really ambitious, you could even move the water area from the darker image into the lighter image, combining the two shots to create one perfectly balanced frame.)

HOW TO READ HISTOGRAMS

Most digital cameras allow you to view what's called a "histogram" for each image you shoot. Using this graphic representation of the tones in your image, it's easy to get a good idea of where there might be problems.

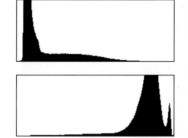

Here's the idea: in the histogram, the image is broken down into tones that are represented from left (pure black) to right (pure white). Tones in the middle area are called "midtones" (somewhere between black and white). The taller the jagged black data is over a given area of this black-to-white scale, the more tones in the image fall into that range. For example, in the first histogram (top) most of the tones are to the far left. This tells you that most of the image is

very dark. In the second example (center), most of the data is over the light areas, telling you that the image is mostly very light. In the final example (bottom), we see a more typical arrangement—some light, some dark, but most tones somewhere in the middle.

The histogram you see will be different for each image—and there's no "right" histogram. What you should look for in terms of exposure, however, is a histogram that tapers down toward the ends (even if it tapers steeply) and doesn't crowd up over the pure white or pure black endpoints (the extreme ends). If it does, this can be a sign of loss of important image detail in either the highlights or shadows.

the highlight and shadow areas. This is because digital has an annoying tendency to "blow out" (render as pure, bald white with no detail) the bright highlight areas in a scene. The results can be really unattractive—as you can see in the photo shown at the bottom left of the facing page.

If this sounds kind of foreboding, don't worry—there are a lot of great things about digital that, ultimately, make it easier than ever before to get a well-exposed image.

The process is really just this simple: meter for a highlight area in your scene. In a landscape image, this might be the clouds, a bright reflection on the water, or a white patch of snow.

If you are using a camera in the manual mode, set your aperture and shutter speed to the metered reading for the highlight area. If using a camera in the auto mode, use the exposure lock to meter and lock in the highlight exposure. (For more on exposure modes, see lesson 19.) Then, shoot your picture.

In the image review mode, examine the highlights carefully. Many cameras let you zoom in on the image to see more detail. Because blown-out highlights are a known issue with digital, many models let you review your images in a mode where areas of pure white with no detail blink in the preview. Other cameras let you look at a histogram of the image (see box to the left).

If you spot a problem with the highlights, reshoot the image at a faster shutter speed or smaller aperture. Many cameras also offer exposure compensation controls; if you are shooting in the auto mode, this is a good way to reduce the exposure of the image to control the highlights.

19. Exposure Modes

Most digital cameras feature several exposure modes. The list that follows includes some of the most common ones. Check your camera's manual for details on your specific model.

AUTO

Usually indicated by "auto" on the exposure mode dial or menu, in this mode the camera makes all the decisions for you. With today's sophisticated metering systems, this often provides a very good exposure.

PROGRAM

The program mode (indicated by a P) is very similar to the auto mode but usually allows you to control *some* settings (like white balance, ISO, etc.).

SHUTTER PRIORITY

In this mode (commonly indicated by "Tv"), you select the shutter speed and the camera selects the best aperture setting (see lesson 23) to match the brightness of the scene. Choose a short shutter speed to freeze moving subjects, or a long one to blur them.

APERTURE PRIORITY

This mode is usually denoted by an "Av" on the exposure dial or menu. It allows you to select the aperture (controlling the depth of

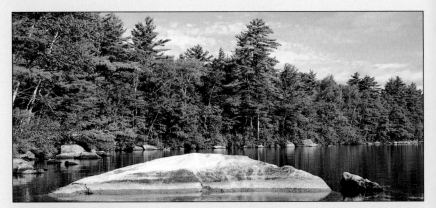

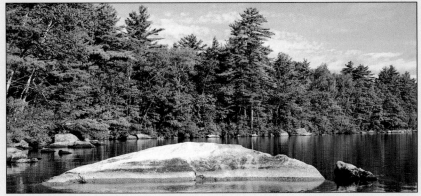

field—see lesson 23) while the camera sets the shutter speed.

MANUAL

In this mode (indicated by an "M"), you control all the settings and have complete control.

PORTRAIT

When shooting in the portrait mode (indicated by the profile of a face), the camera selects a

The top image was shot in the auto mode. The bottom image was shot after switching the camera into the vivid color mode. As you can see, the greens and blues are significantly more vibrant.

wide aperture to keep the subject in focus while blurring the background. When shooting pictures of flowers, trees, and other subjects, this can be a useful setting. The background will grow progressively less distinct as you adjust the focal length toward telephoto (zoom in).

LANDSCAPE

In the landscape mode (usually indicated by a mountain and clouds icon), a narrow aperture is selected to increase the depth of field (see lesson 23). This can result in longer shutter speeds, so it's advisable to use a tripod to minimize camera movement. This mode works well for expansive landscape scenes.

NIGHT PORTRAIT

The night portrait mode is usually denoted by a profile of a face with a moon and stars next to

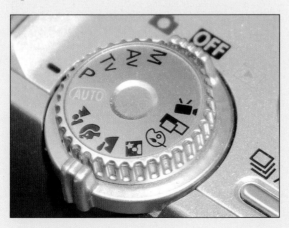

On most models, the exposure modes are selected from a dial on the top of the camera.

it. This mode is used to take a well-exposed image of a subject against a night scene. To do this, the camera's flash is used to illuminate the subject. The shutter speed, which is usually matched to the duration of the flash, is then left open a bit longer to allow the less powerful ambient light (light from the moon, street lamps, windows, etc.) to register in the image.

BLACK & WHITE OR COLOR EFFECT

Often indicated by a palette and brush, this mode allows you to select from color options that may include shooting in black & white or a sepia-tone as well as vivid color (enhanced color saturation and contrast) or neutral color (subdued color saturation and contrast).

PANORAMIC OR STITCH MODE

For more on this mode, see lesson 52.

CLOSE-FOCUSING

Indicated by a flower icon, this mode lets you focus with your lens very close to your subject.

CONTINUOUS

This mode is normally indicated by a stack of rectangles (representing multiple photos) and lets you shoot successive frames for as long as the shutter button is pressed (until the camera or memory card runs out of memory).

20. The Importance of Bracketing

Bracketing your exposures means taking a few shots at different exposure settings in order to ensure that at least one of the images is properly exposed. While this is less of an issue with digital than film (where you couldn't check the exposure on the spot—you had to wait for your film to come back from the lab to see if your images were properly exposed), it's still a good habit to get into.

Why? Well, first, on-camera LCDs are small and can be a little hard to see. They are great for spotting big problems, but when it comes to a detailed analysis of a shot, seeing it on a big computer monitor makes things much easier. Second, you might change your mind or like an exposure setting you didn't expect—some scenes look great a little over- or underexposed, but if you don't try out these exposure settings you'll never know for sure. Finally, why not? With digital, it doesn't cost you a cent to take three or four (or a dozen) shots of a scene instead of just one. Once you've composed a shot, bracketing your exposures only takes a few extra seconds and will give you many more options when you get home and start to review and edit your images.

HOW TO DO IT

If your camera offers manual settings, you can bracket by selecting different apertures and shutter speeds (wider apertures and longer shutter speeds increase the exposure; smaller apertures and shorter shutter speeds reduce it).

If your camera has only automatic exposure settings, try metering for lighter and darker areas in the scene to change the exposure. For instance, instead of metering off the dark-grey mountains in the distance, try metering off the blue sky, a patch of trees on the mountain, the highlight vs. shadow side of the mountain, etc.

THE "CORRECT" EXPOSURE

There is no "correct" exposure for a scene. What is "correct" is the exposure that renders the scene in the way you want to show it to your viewers. This may be quite different than the camera's automatic exposure—but that's just fine. You're the photographer and the choice is yours.

FACING PAGE—The "normal" exposure setting that was recommended by the camera is shown in the center. Bracketed shots showing over- and under-exposure of the same shot are shown above and below. This scene seems to look better when it's just a little bit underexposed—notice how washed out the sky looks in the "correct" exposure.

KEEP IT DRY

Photographing landscapes means exposing your gear to potentially damaging moisture and dirt. Many manufacturers make specialized carrying cases for this

heavy-duty usage. If you're more of a casual shooter, though, some zipper-type plastic bags go a long way toward keeping your camera and lenses dry and clean. Be sure to take your equipment out of the bags when you get home, though, to allow any moisture that may have gotten on the equipment while you had it out shooting to evaporate completely.

One stop overexposed.

Two stops overexposed.

Three stops overexposed.

"Correct" or "normal" exposure.

One stop underexposed.

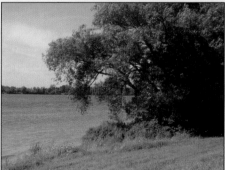

Two stops underexposed.

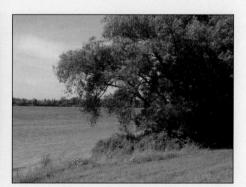

Three stops underexposed.

21. Very Bright and Very Dark Scenes

In order to predict the results you'll get, it's important to understand a little bit about how your in-camera light meter works.

In-camera meters are of a type called "reflected light" meters—meaning they provide a reading of the light that reflects from a subject (as opposed to incident light meters, which measure the light falling on the subject).

Subjects, however, vary in the amount of light they reflect—dark ones reflect little light; bright ones reflect lots. Since the meter can't tell whether you are pointing it at a snow bank or the night sky, it's programmed to assume that you are photographing an "average" tonality and to provide an exposure that will render it correctly.

So what's an "average" tonality? Well, when light meters were first developed, a lot of research was done on that and it was determined that if you averaged all the tones in most images, the value you get would be a medium gray (colors don't really play a role in this since meters "see" only light tones and dark tones—sort of like a black & white picture). Therefore, meters were designed to provide a correct exposure when photographing this tonality—and for the vast majority of scenes, that works quite well.

The problem occurs, however, when your scene just isn't "average." When a scene is very bright, the meter thinks it's actually an "average" scene with *lots* of light on it. As a result, it will underexpose the scene, trying to render the bright tones as much darker. Conversely, the meter sees a dark scene as an "average" subject with very little light on it and will overexpose the scene in an attempt to brighten the dark tones.

If your camera offers exposure compensation, you can correct for this by setting the camera to overexpose by a stop or two when photographing a bright scene, or underexpose when photographing a dark one. If your camera has manual settings, you can use a wider aperture and/or longer shutter speed to increase the exposure, or a smaller aperture and/or shorter shutter speed to decrease it.

GRAY CARDS

Gray cards are stiff pieces of cardboard that are middle gray on at least one side. These are sold at most camera stores. Why would you want one?

Well, using a gray card can actually make metering some tricky scenes a little bit easier. As you learned in this lesson, in-camera light meters are designed to measure the light bouncing off a subject or scene. Unfortunately, different surfaces reflect different amounts of light and your meter has no way to know exactly what kind of surface you're pointing it at—it could be a snow bank, it could be dark, mossy rock.

Because of this, in-camera light meters assume you are metering an "average" tone—middle gray. Using a gray card, which is middle gray, you can ensure that this is actually the case.

Simply place the card in the same light as your subject, meter the card, and then use the same aperture and shutter-speed settings to take your final picture. This technique eliminates a lot of guesswork.

These ice-covered trees were photographed against a bright sky, a scene that tricked the meter into underexposing the shot. The result is an image (left) that is too dark. By choosing the manual exposure mode on the camera, it was possible to create a better exposure (right).

Night shots can be tricky—your camera will want to either use the flash (which you'll need to disable) or choose an exposure setting that overexposes the scene (making it too light, like the one on the left). Choosing the manual exposure mode (or using exposure compensation settings), you can usually get much better results (right). If you're not satisfied, you can tweak the exposure using your image-editing software.

22. Focusing Techniques

AUTOFOCUS

The autofocus systems on today's cameras are extremely sophisticated and provide great results for most scenes. There are still a few things that can trip them up, though. These include: very low contrast subjects, scenes or subjects that mix close and far objects, scenes with extremely bright subjects at the center of the composition, and subjects that are moving quickly.

FOCUS LOCK

Many of the aforementioned problems can be solved using focus lock. To do this, aim your camera at a second subject that is about the same distance from the camera as the intended subject. Focus on this and press the shutter button halfway down to lock the focus setting. Keeping the button half pressed, compose the image, and shoot.

MANUAL FOCUS

For really tricky subjects, you may prefer to use manual focus. On a point-and-shoot camera (if it's offered) this can be a bit tricky, so consult your manual for tips and evaluate your images carefully to ensure you've focused correctly. (If your camera allows it, zoom in on the preview image on the LCD and double-check any areas where the focus is critical). On an SLR, simply

The close-focusing setting on a point-and-shoot camera lets you get quite near small subjects and still keep them in focus.

The point of focus in your image helps the viewer understand what the subject of the image is. In the image on the left, it's the autumn leaves floating on the stream. In the image on the right, it's the yellow vine twining around the metal handrail.

switch to manual focus mode and adjust the focusing ring on your lens until the indicator on your view screen indicates that the image is correctly focused.

ADVANCED FOCUSING FEATURES

Many DSLRs now offer really advanced focusing features that allow you to quickly shift the focus to an off-center subject or even to auto-matically track a moving subject and retain focus. If your camera offers these features, learn how they work and put them to use!

SHARPENING

If your focus is close but not quite perfect, most digital imaging software can help you to improve it. See lesson 46.

SAFETY

For those who like to work in remote, unspoiled areas, photographing landscapes has inherent risks. After all, something as simple as a sprained ankle can be a serious affair when it happens ten miles out on a trail.

Before you head out, it pays to brush up on your survival skills. Check the weather for the day and dress appropriately, so you won't get frost-bitten or suffer from sunstroke. Wear comfortable, sturdy shoes or boots that provide good support. Don't forget to pack water and some snacks, just in case. If possible, bring a friend (or at the very least, your cell phone). Consider purchasing a GPS system to help you navigate. Before you leave, let someone know exactly where you are going and when you plan to be back—and stick to your plans!

As you shoot, remember that it's remarkably easy to get so caught up in the beautiful scene you're watching in your viewfinder that you don't notice the huge branch about to whack you in the head, the ground starting to give way under your feet, or the hungry grizzly bear standing behind you. Enjoy taking your images and have fun—but don't ignore the environment as you do so.

23. Aperture and Depth of Field

The aperture of a lens is the size of the opening through which light passes to hit the imaging sensor and create an image. Apertures are denoted by "f" numbers—like "f/8" or "f/16." The larger the "f" number, the smaller the aperture (so f/16 is actually a smaller lens opening than f/8). If your camera offers manual exposure settings, you may be able to select the precise aperture you want; if it does not, you may be able to control the way the camera selects the lens aperture through your choice of exposure mode (see lesson 19).

The size of the aperture directly affects the image's depth of field—the range of sharp focus. For example, with a very wide aperture setting the range of focus is very narrow—a single flower may be in focus, while the blades of grass in front of and behind the blossom are blurred. At a very narrow aperture, the depth of field can be much greater—everything in the scene, from the tree in the foreground to the mountains in the far distance, may be totally sharp.

Knowing this can help you to sculpt interesting compositions that emphasize your subject by keeping it in focus and minimize distractions by letting them fall out of focus. It can also help you increase the sense of depth in your image, since background elements that fall out of focus tend to look far away.

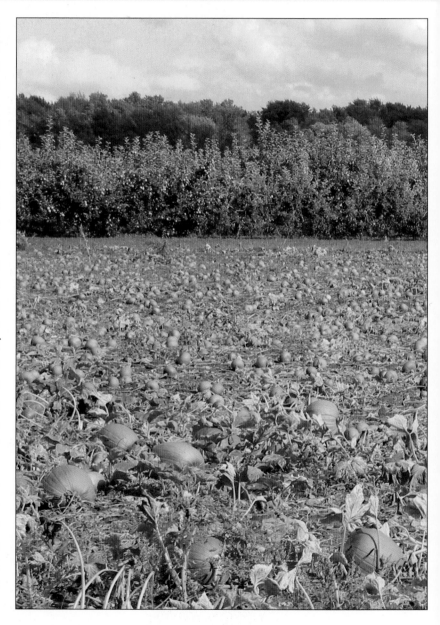

FACING PAGE—Using a narrow aperture produces a wide range of focus. In this image, both the pumpkins and the apple trees are in focus. It's not until we hit the more distant row of darker trees that the focus is significantly reduced.

RIGHT—Using a wide aperture lets you create a narrow band of focus in your image—so only the subject you focus on remains sharp and all the other elements fall out of focus.

24. The Basics of Light

You can buy the most expensive gear in the world and travel to the most exotic locations on the planet—but wherever and however you take them, all photographs are ultimately the product of light. (In fact, the word "photograph" means "light writing.") It would be almost impossible to overestimate the importance of light in creating top-notch images. Learning to understand it is therefore a critical skill for photographers.

QUALITY

Light can be either hard or soft (or somewhere in between).

Hard light comes from a source that is small in relation to the subject and creates crisp, dark shadows with well-defined edges. Think of the shadows formed by the noontime sun on a cloudless day. Even though the sun is very big, because it is so far away it is actually small in relation to subjects here on Earth. Therefore it casts dark, distinct shadows. On-camera flash is also a small source, and it produces similar shadows.

Soft light comes from a source that is large in relation to the subject. Since landscapes are usually, well, *huge*, you can imagine it takes a pretty big light source to produce soft lighting

Here we see two versions of the same subject. The only difference is the lighting—but what a difference! In the image on the left, the mossy rock was photographed in glaring, direct sunlight. This is a hard light source, which creates sharp, dark shadows. In the image on the right, the rock was photographed in very soft light, so the shadows are lighter and more gentle, but the colors are also somewhat less vibrant.

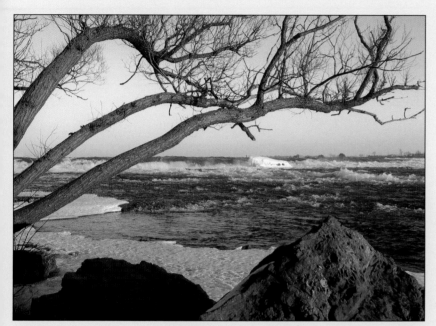

In this scene, the light came from behind and to the right of the camera. The shadows reveal that the sun was low in the sky—as does the golden color of the light.

shadows' darkness and crispness, the *direction* from which the light strikes a scene will determine the angle and length of the shadows.

Light that comes at least somewhat from the side tends to be the best for creating shadows that reveal the shapes of subjects and make them look three-dimensional. With the sun, this means shooting in the morning or evening (not at midday when the sun is overhead).

If your subject is a deep valley or canyon (or in one), you may need to shoot when the sun is at less of an angle in order to ensure that the bottom of the valley or canyon is adequately illuminated.

With hard light, since the shadows tend to be darker, the direction of the light is usually very obvious. With softer light (especially when shooting on an overcast day) the light may be harder to discern—with shadows that are nearly invisible.

COLOR

Although our eyes are designed by evolution to compensate for it to a great degree, the color of daylight does change over the course of the day. When the sun is close to the horizon, it tends to be more orange or gold (warmer). At noon, on the other hand, it tends to be more blue (cooler). For more on the color of light, see lesson 30.

on a landscape. This type of lighting exists when the sun is filtered through clouds or trees or when the sun is below the horizon and its glow illuminates the sky (which in turn lights the landscape). Under these conditions, the light source is actually the entire sky—a very big light source indeed.

DIRECTION

Light also has direction. It can come from above, behind, below, to the left or right, etc. While the *quality* of light will determine the

25. Morning

Early morning, from the time the glow of dawn appears on the horizon until about an hour after sunrise, is one of the nicest times of the day to take landscape photographs.

Morning light—especially when the sun is very close to the horizon—is usually quite diffuse, meaning that it creates soft, delicate shadows. This can be quite nice for many landscape subjects. It works especially well for scenes where the shadow from one subject might otherwise obscure another subject.

It also tends to produce gentle renditions of color, with tones that are less saturated than at midday. For scenes that feature pale colors, this can be very flattering.

As the sun rises just above the horizon, the shadows become a bit darker and more directional. Because the sunlight will illuminate your

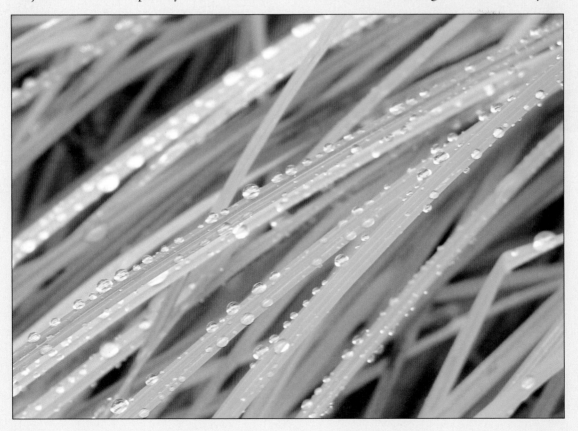

Droplets from an overnight shower still cling to these long blades of grass, photographed very early one summer morning. Using the close-focusing setting on a point-and-shoot digital camera allowed for correct focusing. Note the strong diagonal lines used in the composition.

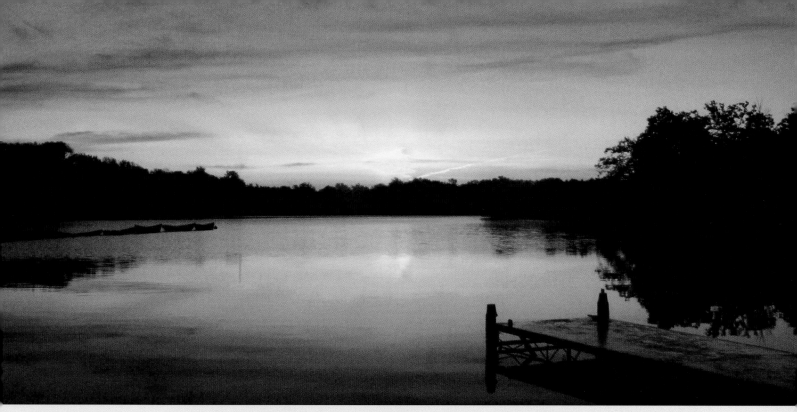

Reflected on the smooth surface of a lake, the colors in the sky are doubled in the image.

subject from the side, this is a good time to shoot images where gentle shadows are needed to show the shape or texture of your subject.

SPECIAL SUBJECTS

Some subjects are only available to shoot in the morning—there are a number of flowers, for example, that only bloom at this time of day.

In warm times of the year, morning is often the time to take advantage of the sparkle and shimmer of dew on plants and trees. In winter, morning may reveal frost-covered trees that also make excellent landscape subjects—whether you photograph a whole hillside or a single, crystal-covered leaf.

It may seem obvious, but morning also tends to be a good time to photograph east-facing subjects. If you wait until later in the day, you can find yourself working in a backlit situation that is less than optimal (see lesson 28).

IN-CAMERA EXPOSURE DATA

One of the useful features on many cameras is the ability to automatically record and review information about your images. It might not surprise you to learn that all of the files include information about the date and time they were taken, but did you know that your camera may also record the aperture, shutter speed, white-balance setting, and other information about each shot? Check your manual to see how this data can be accessed and take a look at it. If you're having trouble with a shot (especially when shooting in the auto mode) you may be able to look at the settings the camera chose, then adjust them slightly to take a better photograph in the manual mode.

26. Midday

Midday, when the sun is relatively high in the sky, is when most people tend to take the majority of their photos—after all, it's when most of us are out and about. There's certainly nothing wrong with midday photos, but if you want to take more successful landscape images you should make the effort to shoot at other times of the day as well.

In the middle of the day, the light comes from a high angle. If it is not filtered through clouds or trees, it can be very bright and harsh. The shadows it forms will be quite dark and well defined.

Midday light also tends to be cool in color (tending toward blue). This can be particularly apparent in shadow areas that sometimes render as distinctly blue. This isn't a problem for a lot of images, but it could cause real problems if you wanted to create an image that conveyed a sense of warmth.

With midday light, watch out for "hot spots" (very bright areas) in your image. These can be very distracting.

SPECIAL SUBJECTS

You can use the harsh quality of midday light to great advantage. For example, the colors under this kind of light tend to be very saturated and intense—so it can be perfect for photographing flowers and colorful leaves.

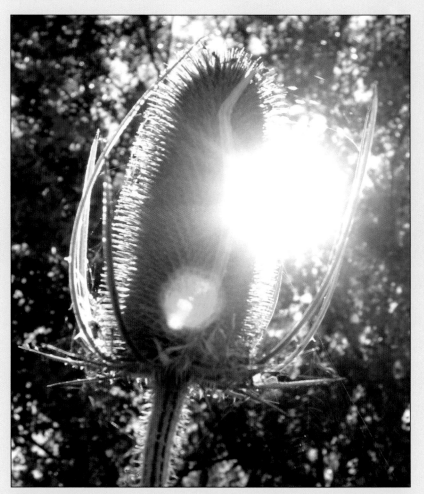

When the sun itself is in the frame (or very close to being in the frame), lens flare can be the result. This is characterized by a loss of contrast (washed-out areas) and bright spots (usually a string of small circles in a straight line). Lens flare is almost always something to be avoided, but it can occasionally be used creatively. Use this technique sparingly and with caution—especially if your camera's manual recommends avoiding it due to potential damage to the image sensor. If your camera accepts filters, you can purchase a lens shade that mounts over your lens and helps prevent extraneous light from hitting the image sensor.

This type of light can also be very good for scenes where you want to achieve an extremely high degree of contrast in order to make your subject look more graphic. Imagine, for instance, a tangle of branches where the highlight areas are almost pure white and the shadow areas are almost pure black—the effect could be quite striking!

Midday light can also be perfect for images where you want to communicate a sense of the harshness of the environment. In images of the desert, for example, harsh light can help to suggest the intensity of the environment—and maybe even the heat. In winter scenes, harsh light seems to emphasize how stark and motionless—almost devoid of life—the landscape appears. In these types of scenes, you may even want to include the sun in the frame and experiment with the effects of lens flare (see facing page).

Finally, midday light can work well when you want to show glare (on ice, wet subjects, shiny rocks, etc.). It also can be effective when photographing reflections in water, since it tends to enhance the crispness and color saturation of the reflected subject.

Midday light works well for subjects where you want strong, dark shadows. Here, the shadows help show the shape of the rocks in South Dakota's Custer State Park (in the legendary Black Hills region).

27. Late Afternoon and Sunsets

Like morning light, late-day light tends to be soft and directional—especially in the hour just before sunset and the hour or so just after (until the light fades too much to comfortably make exposures using only the available light).

In the evening, the sky is often beautifully colored—either with reds or oranges, or with deep, rich blues. On its own, the evening sky can be used as the subject of lovely images. It can also be used as a wonderful backdrop for images of the landscape.

While morning tends to have a sense of potential, with the world just waking up and getting ready to spring into action, evening shots have more of a sense of rest and tranquility. Consider looking for ways to communicate this in your images.

SPECIAL SUBJECTS

As the sun begins to drop in the middle to late afternoon, you may find that the light is right for photographing west-facing subjects.

Trees, either with or without their leaves, often look good silhouetted against a cloudy evening sky.

When a dramatic sky is reflected on water, you double the area of color in your image.

Evening is also a good time to photograph silhouettes (see lesson 28). Rows of trees, sailboats, skylines, and other easily recognized shapes look wonderful silhoutted against a vibrant evening sky.

Of course, the most prominent type of evening image is the sunset—who doesn't have at least a few of these dazzling scenes in their photo album? For the best results (and the most vibrant colors), meter for a very light area of the sky. You may even want to set your camera to the vibrant color mode, if your model offers such a setting. You can also experiment with various white-balance settings to see how they affect the colors. (A great thing about sunsets is that they look different every day, so you don't have to worry about color accuracy.)

Don't forget to compose your sunset shots carefully—there are lots of colors and shapes in these scenes, so look for ways to make them engage the viewer's eyes.

One of the nicest places to shoot sunsets is the Eastern shore of a large body of water—a wide river, a lake, or even the ocean. With the water reflecting the colorful tones in the sky, the scene becomes almost larger than life.

28. Backlighting and Silhouettes

Most subjects are best photographed when the sun is behind the camera and falling past it onto the front of the flower, waterfall, mountain, etc. This is also the easiest scenario in which to meter the light for a pleasing exposure.

However, the placement of some subjects and the time of day at which we arrive to photograph them can often make this impossible. Instead, we have to work with backlighting—a situation in which the light is in front of the camera and strikes the back of the subject.

The problem with this situation is that it leaves the front of the subject (the side being photographed) in shade. If you expose for the bright background behind the subject, the front of the subject will be underexposed (too dark); if you meter for the subject, the background will be overexposed (too light). There are a few solutions.

You might be able to compose an image in such a way that none of the background shows. For example, instead of photographing the entire tree, you could fill the frame with just the bark or just a leaf. Instead of photographing the shape of the mountain against the sky, you could photograph the patterns that the trees or rocks make on the side of the mountain (then come back earlier on another day to capture the intended image when the light makes it more feasible).

When this mountaintop weather station and the rocks around it were properly exposed, the ominous storm clouds above it were too light (top). It was better to expose for the sky and brighten the rocks a little bit in Adobe Photoshop Elements (see lesson 45).

If you can't compromise on the composition, you could expose for the most important area of the image and simply live with the exposure problems elsewhere.

If the overexposure on the background isn't too extreme, you might be able to correct it after the fact using your digital-imaging software (see lesson 44). Where the exposure difference between the subject and background is extreme, you could take two shots, one with the subject well exposed and one with the background well exposed, and then combine the correctly exposed areas of each image using your digital-imaging software.

You could also consider using a graduated neutral density filter. This type of filter (which fades from gray to clear) is designed to block some of the light from half of the frame. Looking through the LCD or viewfinder, turn the filter until the gray area is positioned over the area that is too bright (usually the sky), then expose for the subject. By blocking some light from the top of the photo and none from the bottom, the filter will help reduce the exposure on the sky and prevent it from being too bright.

In some situations, backlighting can be used to create a very dramatic effect. In the image above, the sun (filtered through leaves) appears as a starburst at the lower right corner of the image and the autumn trees are almost silhouetted against the blue sky.

SILHOUETTES

Silhouettes are the result of backlighting taken to its most extreme. With the proper subject, though, silhouetted images can be very striking. To create a silhouette, look for a backlit subject with a great shape—you won't see color or texture in the subject, so shape is all that's important. Then, frame it so that all you see behind it is sky (maybe even a colorful sunset!). Next, meter for a light area of the sky and expose the shot. Metering for the sky ensures that the subject will be rendered as very dark.

29. Night Landscapes

If you're up for a challenge, give night photography a try. Perfecting your exposures will definitely take some experimentation, but the resulting images can be quite dramatic.

LOW LIGHT

At night, you'll likely make your exposures using moonlight, starlight—maybe even fireflies. What do these light sources have in common? They don't produce very much light.

As a result, you'll need to be prepared for long exposures (maybe measured in minutes rather than fractions of a second). If you're interested in taking this type of image, you'll need to make sure your camera is capable of these long shutter speeds. Second, you'll *definitely* need a tripod, since any camera jiggle at all will create blurriness.

The great thing about shooting night images digitally is that you can instantly check your exposure. If the image is too light, just reduce the shutter speed. It it's too dark, you can increase it. Be prepared to experiment!

BRIGHTER LIGHT

Some night subjects have a bit more light—which works out well for cameras that don't offer very long shutter speeds. Fireworks, for example, can be photographed at the shutter speeds available on most point-and-shoot cameras. City lights—especially skylines—also make good subjects for nighttime images. Even with these brighter light sources, however, you'll want to make sure to shoot from a tripod to eliminate camera movement.

SPECIAL SUBJECTS

There are some flowers that bloom only in darkness—like the evening primrose, the moonflower, and the night-blooming cereus, which saves its flowers for night because it is pollinated by bats. Keep an eye open for these and you may be able to create some interesting images.

Since night images involve long exposures, you also have a chance to show motion in a uniquely photographic way—a way the human eye simply can't. To do this, look for moving sources of light—like car headlights, reflections on moving water, a field full of fireflies, etc. By capturing these at slow shutter speeds, you can render them as trails and swirls of light.

Astrophotographers use extremely long exposures to photograph star trails—although in these images it's the motion of the earth that makes the stars seem to streak across the sky.. Since the earth rotates pretty slowly in relation to the stars, the exposures used for such shots are often measured in hours rather than seconds or even minutes.

FACING PAGE—Night shots are easiest to create when there is some source of manmade light. Here, city lights are reflected in a river, while the pale glow of the sun was still just visible on the horizon.

30. White-Balance Settings

If you're at all familiar with film photography, you've probably noticed that the film you buy (or used to buy) is labeled either "daylight balanced" or "tungsten balanced."

As was noted in lesson 24, light comes in different colors—morning and evening daylight are warmer than midday light, for example. Man-made light sources also vary in their coloration. In order to ensure that the colors in your image come out looking the way you anticipated, films are therefore color-balanced to coordinate with one particular color of light—either daylight or tungsten.

Daylight-balanced film is color balanced for midday light. If you shoot it at sunset, though, everything will have a pink cast (which might be just what you want). If you shoot it under tungsten light (regular household light), everything will have a yellow cast. To get accurate colors under tungsten light, you need to switch to tungsten-balanced film.

The white-balance settings on a digital camera work pretty much the same way—but with some major advantages!

First, on most digital cameras you'll find that you have a lot more choices at your finger-

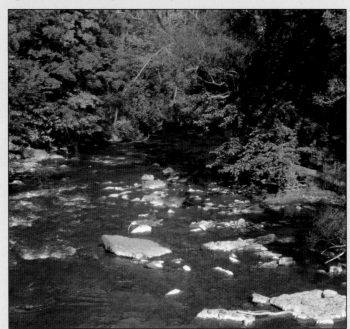

Daylight white-balance setting.

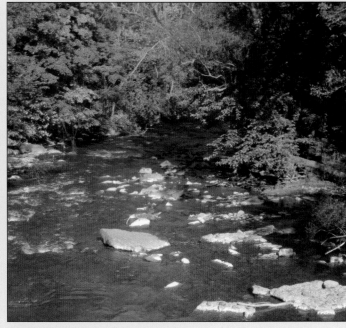

Cloudy-day white-balance setting.

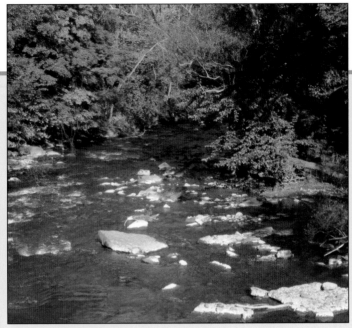

Tungsten white-balance setting.

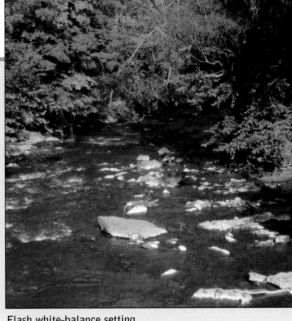

Flash white-balance setting.

tips than just daylight and tungsten. Most models include: auto (where the camera evaluates the scene and picks the setting it thinks is best); daylight (for photography outdoors on a bright day); cloudy or overcast (for overcast, shady, or twilight conditions); tungsten (for images by normal household bulbs); fluorescent (for warm-white or cool-white fluorescent lighting); fluorescent H (for photography under daylight fluorescent lighting); and flash (for, you guessed it, flash photography).

Many cameras also include a custom white-balance setting that lets you obtain the best color reproduction in situations where you feel the preset options don't do the scene justice. To create a custom white-balance setting, take a reading off a white area in the scene. If there is no white area, you can put a white piece of paper in the same light as is falling on your subject and take a reading off it.

Keep in mind that just as there is no one "correct" exposure, there's no one "correct" white-balance setting. If precise color rendition is important to you, you'll choose a setting that closely matches the lighting, thereby neutralizing potential color casts. If mood is more important, you might choose different settings to shift the colors in creative ways. Selecting the tungsten setting when shooting under daylight conditions will give your image(s) a blue cast, for example.

In fact, another great thing about digital is that you can change the white-balance setting with every shot, so feel free to experiment!

31. Spring

In the spring, green starts to reappear on trees, bushes, and lawns that have been brown or snow-covered through the winter. A sure sign of spring is the appearance of spring flowers—like daffodils, crocuses, and tulips. These colorful elements can be photographed alone or contrasted with the still-wintery world around them to show the turning of the season. Here are some tips:

1. Spring landscapes are about the return of color and life to the world. The colors can be subtle (pale green buds on trees) or vibrant (bright yellow, blue, and purple flowers). Try to capture both aspects.
2. Spring is really in the details. Vast, wide-angle shots often miss the spots of color and the subtleties that typify the season, so consider doing more close-ups and mid-range shots at this time of year.
3. Early in the season, look for opportunities to juxtapose spring and winter. With late snowfalls, it's not uncommon to see ice clinging to spring flowers or new growth popping up through a blanket of snow.
4. Keep an eye open for special seasonal events in your area. The blooming of the cherry trees in Washington, D.C., for example, is a fleeting spring event that offers great landscape opportunities.

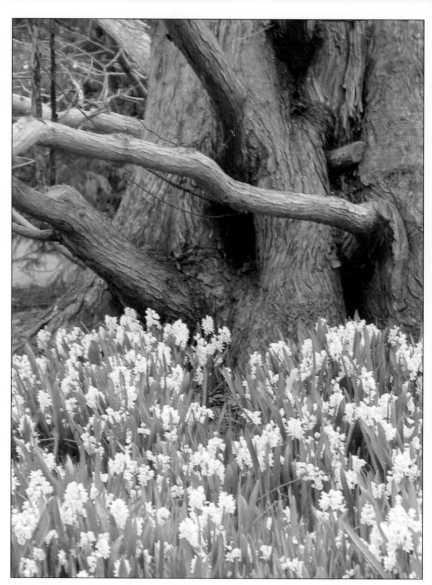

In this image, pale blue flowers and vibrant green leaves are contrasted with the gnarled trunk and leafless branches of a tree in early spring.

Daffodils are a sure sign of spring in many parts of North America. They can be photographed individually or as part of a wider landscape shot. In the image to the right, the flowers, sprouting grass, and budding shrubs are all indicative of spring.

Many spring flowers are quite small. Close-up images can help you show these to viewers in a way that most people would never see them.

32. Summer

Summer is about sunshine and warmth. In many places, that is reflected in lush foliage and bright colors; in others, it is demonstrated by dryness and drought. Here are some tips:

1. Summer tends to be when most of us take our vacations—and when we take most of our pictures. If you'll be headed out to a beautiful location, take extra batteries and memory cards so you won't miss a shot. If the place is new to you, do a little research on spots that might be good for photography. When you spot great landscape images in tourism brochures or travel books, take a few notes on where they were shot.
2. Look for subjects that show the vibrancy of summer—thick foliage surrounding a scenic stream, manicured gardens, rolling hills of thick, green grass, etc.
3. Summer is a great time for sunset photography, since the sun drops well after most of us are done with work or dinner. Take a drive to a scenic location and set up for sunset (then stick around for some evening shots as well).
4. Most gardens and parks are in their prime in the summer, so take the time to visit ones in your area that you might have neglected for a while. Keep an eye out for any special outdoor events!

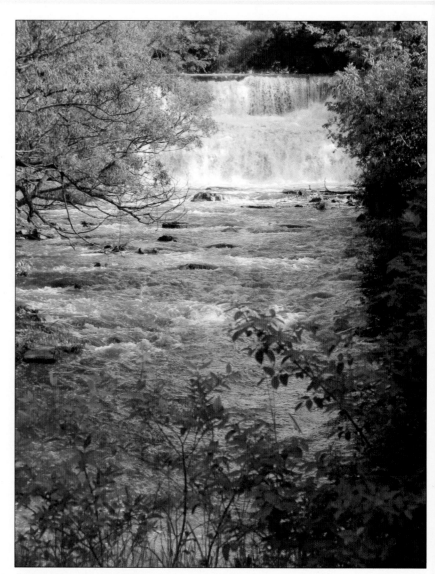

Lush foliage and abundant water are typical of early summer landscapes in many areas. Here, foliage was used to frame the waterfall and stream. The waterfall was composed in the top area of the image, allowing the stream to flow down toward the viewer.

ABOVE—Doing a little research before your vacation will help ensure you don't miss great subjects.

RIGHT—Lush foliage and flowers are typical of summer.

33. Autumn

The first thing that comes to mind when most people think of autumn is bright red and orange leaves—but there's more to autumn, as well. Autumn is harvest time, for example. It's also when many bird species begin to migrate. Here are some tips:

1. Autumn leaves are one of the most popular subjects in landscape photography—and they can certainly be stunning. Look for vibrant colors and pleasing compositions. Most people have seen lots of these photos though, so if you really want to engage your viewer, look for images that will show them this familiar subject is a new way.

 For especially vibrant color, try photographing fall foliage at dawn or sunset when the light is quite red. You can also switch your white-balance setting to finesse the colors. If your camera has an exposure setting for vibrant colors, try using it.

2. Autumn is a great season for photographing farmlands. Fields of pumpkins, red apples on trees, hillsides dotted with golden bales of hay—these are all great subjects for landscape photography.

3. What could say "autumn" better than topping your landscape image with a sky filled with migrating birds (especially geese in their V-shaped flight pattern)?

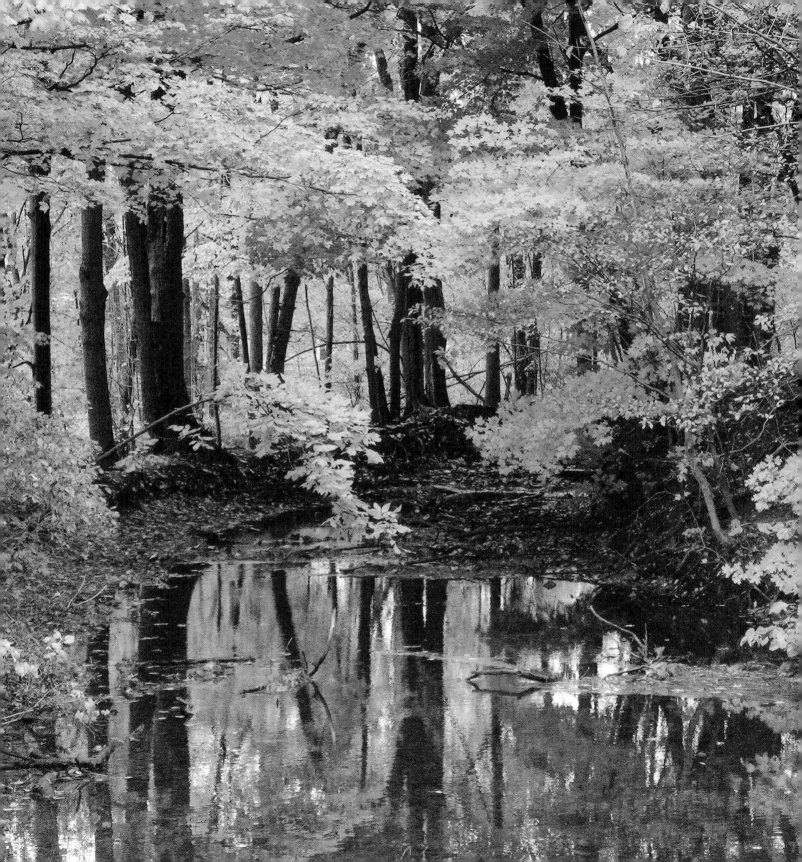

34. Winter

In most parts of North America, winter means snow, ice, glistening sun, barren fields, and leafless trees. Capturing this in your images can be a great challenge—and one that many landscape photographers overlook. Here are a few tips:

1. Winter landscapes usually offer little color, so plan your compositions carefully, using shapes and texture to create interest.
2. Try to keep your camera body warm—if your batteries freeze, your shoot could end earlier than planned! Hold the camera close to your body when it's not in use.
3. Like eyeglasses, lenses can fog up with rapid changes in temperature. Give them a few minutes to clear up if this happens.
4. When photographing snow, check your LCD frequently—getting the right exposure can be tricky. You may need to use exposure compensation to slightly increase the exposure, since in-camera meters tend to underexpose snow. If your camera has an image-review setting that allows you to identify blown-out highlights, this is the time to use it to ensure you don't go too far and overexpose the snow.

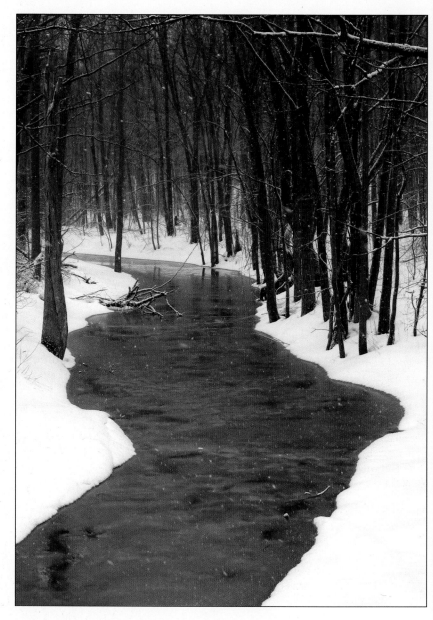

As it makes its way through the snow and leafless trees, the curving line of this stream creates a nice leading line (see lesson 13).

The top image was made just after shooting images near a series of rapids on the Niagara River. Light mist on the lens created a sparkling effect when it was pointed toward the sun. (Note: It's never a good idea to get your lens wet. In this case it was inadvertent, and the lens was dried immediately after taking this shot.)

ABOVE—This is a frozen waterfall. It was snowing when the shot was taken, which isn't the optimal way to capture most scenes. A return trip was planned a week later, but warm weather had already claimed most of the ice. (A summer view of this waterfall is shown in lesson 35.)

RIGHT—Shot early on a frosty morning, an image like this could be created in just about any backyard. Using a wide aperture created a shallow depth of field that rendered the cluttered background of branches as an abstract blur. Notice that the stem runs diagonally through the frame, making it much more interesting than it would have been if framed vertically.

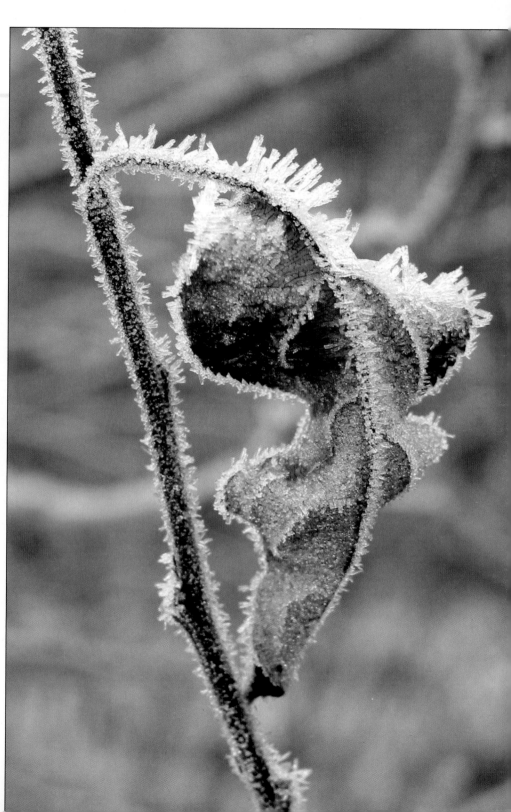

35. Finding Local Landscapes

If you really start looking, you may be totally surprised to find how many great landscapes there are in your area—just waiting for you to come photograph them!

When I started writing this book, I decided it would be a good time to track down some new places to shoot in my area. I went to www.google.com and entered "waterfall" and "Western New York" (where I live) as my search criteria. Now, I thought I knew a lot of the waterfalls in my area—but I was shocked to find out that there were nearly a hundred significant waterfalls within an hour or two drive.

I've since visited quite a few of them. Some have been a little disappointing photographically (obscured by foliage, for example), some have been absolutely stunning. In every case, however, I've had the chance to photograph other landscapes along the way to and from the falls—trickling streams, mossy boulders, rolling hills, etc. Simply having a new destination took me into areas I might never otherwise have thought to go. It just goes to show how a little research can pay off!

BE A TOURIST

When you want to find landscapes in your area, there are a lot of helpful resources you can draw on. First, try to see your region through the eyes of a tourist. Check with your state and/or local tourism bureau to see if they have a web site you can visit. Also, ask them to send you any materials they have for visitors to your area. Look through all the photos (in the booklets and on the web site) and flag the locations of ones you like. This is like letting other photographers do the legwork for you. When you visit one of these sites, you'll know there's at least *one* good photo to be taken there (and chances are, you'll find a lot more!).

THE INTERNET

Next, turn to the Internet and your favorite search engine. Search for the name of your city

DO YOUR HOMEWORK—AND KEEP RECORDS

As you research places in your area that you want to photograph, be sure to keep good records. A three-ring binder works well for notes and printouts. This will save you the frustration of trying to track down a site you wanted to visit . . . but can't quite remember the name of. It's also a good idea to take down the driving directions (if they are given) or use www.mapquest.com to print out your route. Keep this with your information on the site and you'll be ready to go on a moment's notice. When you return from your trip, take a few seconds to make some additional notes—particularly if you liked the site but think it would be better photographed at a different time of day or if you want to return in the summer or autumn for additional shots.

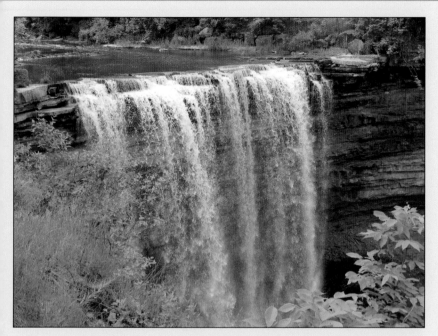

I'd passed an exit sign for this site (Balls Falls in southern Ontario, Canada) dozens of times. For some reason, though, I never bothered to investigate until I saw photos of it on a web site and realized that the falls were much larger than I had imagined. As it turns out, there is actually a series of falls, a pristine stony brook, and lots of great foliage at the site.

or region plus "parks," "waterfalls," "nature preserves," "rivers," "trails," etc. You'll probably find there are a lot of beautiful little spots you've never even heard of! You may even find web sites by other landscape photographers in your area. Take a look at their vision of your region (and click the e-mail link to drop them a line if you like their work!).

BOOKS

In many areas, there are regional publishers that specialize in books for the local outdoor enthusiast. Books for hikers, cyclists, and paddlers are also great resources for landscape pho-tographers, since they tend to cover the scenic areas we're interested in. The regional publisher in my area (Footprint Press) has a wonderful web site with links to sites of interest. They even have a regular e-newsletter with information on trail openings, special events, and other regional concerns.

When looking for books on local topics, check your local bookstore—most have a "local interest" section. Your local camera stores and sporting good stores are also good places to look. On-line, you can do a keyword search for your region or city at any of the major book-sellers' web sites.

PHOTO CLUBS

Just about every area has a photo club (often more than one). Join it and draw on the experiences of the members—and offer your own insights! Check your local camera store or look on-line to track down a club in your area.

FRIENDS AND FAMILY

It's great to take photos with someone, so if you have a friend who likes landscape photography, plan a joint trip—you'll probably learn a lot from each other. Also, different people are familiar with different spots, so ask those around you if they know of any beautiful locations you should photograph.

36. Urban Landscapes

You might not think, "Skyscrapers! Bridges! What a great landscape!" Still, many landscape photographers count these "urban landscapes" among their favorite things to photograph. If you live in a big city or are visiting one, it can definitely be a fun exercise to consider the "urban jungle" around you through the eyes of a landscape photographer.

LENS SELECTION

Taking landscape-style images of cities usually requires using a wide-angle lens (or the widest setting on your zoom lens). This allows you to show the patterns and shapes across a large area rather than the features of a particular building (which is more in the realm of architectural photography—a different book entirely!).

APERTURE

The appeal of most architecture is in its shape and crisp lines rather than in its color or texture. Therefore, you may want to employ a narrow aperture when shooting city landscapes—this ensures the maximum depth of field (see lesson 23).

HAZE

While it can be a problem in all landscape photography, haze seems to be a particularly tricky issue in urban areas—probably because of the increased emissions from cars, factories, etc. Causing a lack of contrast as the scene recedes into the distance, haze can be a real obstacle to great images. The best way to deal with haze is simply to avoid shooting when you can see it's a problem. If that's not an option, you can minimize its impact by using a polarizing filter on your camera. While looking through the lens (or at the image preview on the LCD), rotate the filter until the haze is most minimized. This may also, incidentally, minimize the reflections in the windows of the buildings—which could be a good thing or a bad thing, depending on the look you want.

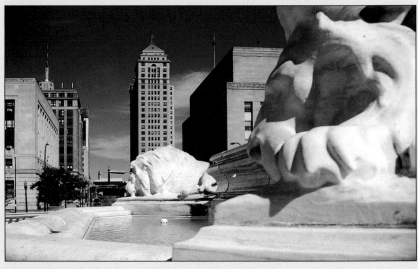

By placing them close to the camera, the lion sculptures were rendered on the same scale as the buildings in the background. Their neutral tone and curved lines contrast nicely with the rectilinear shapes of the buildings.

Placing the camera almost on the ground at the base of the obelisk, the sun was framed behind the monument to create a glow that brings the cloudless sky to life. Tilting the camera enhanced the converging lines of the tall structures.

tortion. Instead, look for sites that are open or allow you to shoot over a wall. Even shooting through a chain-link fence is better than having to shoot through glass (or Plexiglas).

If the city you want to photograph is situated in a valley, you can also try getting above the scene by tracking down any scenic overlooks on the surrounding hills or mountains. In some areas these are abundant (every road into town seems to have a pull-off area with a great view), in others you might have to do a bit more scouting of the back roads to find the right clearing to shoot through.

SKYLINES

Skylines are a great subject for landscape photographers. If the city you are photographing is on a body of water, shooting across this at the city can make a great image. Make sure to keep the horizon line straight to ensure that the buildings won't appear to be in danger of toppling into the water.

TAKE THE HIGH GROUND

It's also helpful if you can shoot from an elevated position. If there are tall buildings in your area, see if any of them offer an observation deck or rooftop garden/restaurant. Many of these areas are glassed in for safety, which can impede photography by causing glare and dis-

NIGHT SHOTS

Because cities tend to be well lit-up at night, they can often be photographed quite easily. Your results will be especially nice if you wait for the moment in late evening when the city lights have come on but there is still some color in the sky.

37. Parks and Farmland

Most of us are so familiar with our environment that we sometimes take it for granted. This makes it easy to overlook the interesting landscape photography subjects that may be (literally) in our own backyards.

When we see astonishing landscape photos taken in exotic locations, it's tempting to say, "Sure, if I had subjects like that, I could take great pictures, too." However, while having an appealing subject is certainly important, what's even more important is how you choose to present it.

In short, it's not necessary to quit your job, pack your camera, and head out into the wilderness to get great landscape photos. There are a lot of great scenes that can be photographed from the side of the road, on walks in city parks, or in gardens.

The three images shown here are a good example of the sheer variety you can create even in a very limited shooting area. The trilliums (three-petaled spring flowers) were photographed in a city picnic area. Using a low camera angle (about four inches off the ground) brought their forest environment into frame. About two feet to the left of the trilliums was a huge tree with a very straight trunk and nice texture on the bark. Placing the camera on the trunk and shooting straight up showcased this and created lots of diagonal lines for a strong composition (see lesson 13). At this point in the morning, it started to rain. The panoramic image below was shot from the car at the entrance to the park, where a golden field across the road contrasted nicely with the dark storm clouds moving in.

The images shown here were all taken within about twenty minutes of each other and within about two miles. You can find interesting landscape subjects just about anywhere—if you keep your eyes open for them.

38. Lakes, Streams, and Rivers

People seem to be naturally drawn to the water. We picnic and play at the beach, hike along riverbeds—and when we get a chance to go on vacation, it's very often to a lake- or ocean-front locale. It's not surprising then that lakes, streams, and rivers are among the most commonly photographed landscape subjects.

To make your images of water stand out from the crowd, consider the following tips:

1. Decide what makes your subject really special. Is it the rocks in the water? The trees bending over the stream? The reflection of the clouds on the lake? Emphasize that feature in your image.
2. *Everybody* shoots from the shore. If you have access to a boat (or if the water is shallow enough to wade), get out on the water! This will give your images a different perspective—and it can make them much more unique and appealing.

3. Look for beautiful skies. Water doesn't really have a color of its own; it reflects the colors around it. For beautiful colors (especially on large bodies of water like lakes and oceans), shoot under pretty, colorful skies.

Lakes, streams, and rivers are among the most popular landscape subjects. Therefore, you need to look for ways to show something different—whether it's unusual rock formations (above), early spring blooms (top), or painterly reflections (facing page).

39. Waterfalls

I happen to be lucky enough to live about twenty minutes away from one of the most famous tourist attractions in the world— Niagara Falls. The shot shown on the facing page was taken from the Maid of the Mist, a boat that takes visitors right up to the base of the falls.

Whether they are majestic, awe-inspiring spectacles like this one or tranquil, silvan streams that trip down a drop of only a few feet, waterfalls are enduring favorites for landscape photographers. Unless you live in a very dry region, there are probably some lovely waterfalls nearby for you to photograph.

When photographing big waterfalls, consider including other elements within the frame so that the viewer will get a sense of the scale of the falls (trees and plants work well).

Unless you are photographing from a bridge or a position on the river, you'll usually be looking at a waterfall from an angle. In such instances, it is nice to position the waterfall to one side of the frame and show the water flowing out of the frame (see lesson 16 for an example of such a composition).

To blur the water, a popular type of image, choose a slow shutter speed. Experiment with the settings until you get the result you want.

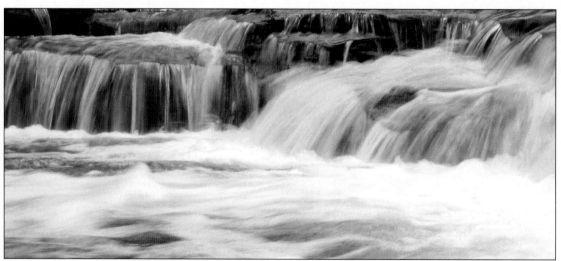

ABOVE—To blur a waterfall, select a shutter speed $1/15$ second or longer. To do this, you may need to switch your camera to the manual mode, then select a narrow aperture and low ISO setting. At long shutter speeds like this, stabilizing the camera completely is a must. This shot was taken with the camera sitting solidly on a flat rock.

FACING PAGE—This image of Niagara Falls was taken from the brink—a great vantage point for photography.

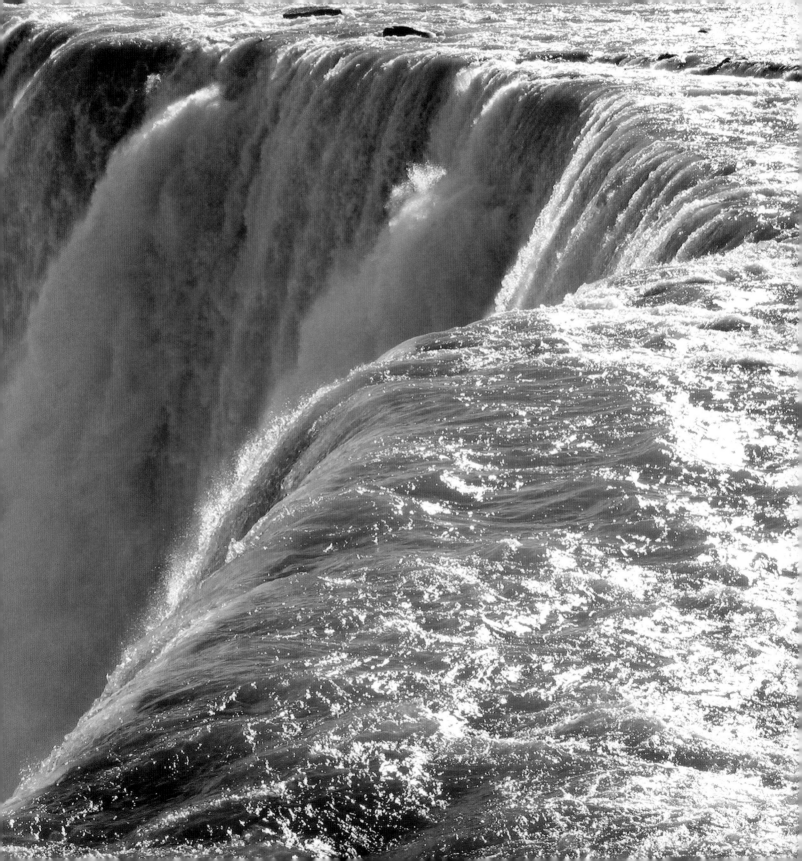

40. Scenic Vistas

Scenic-view roadside pull-offs are a classic stop on the family vacation, but these sites are also great for landscape photographers. Whether in a national park or just along a regional highway, these areas are normally maintained in such a way that you are assured of a clear and unobstructed view of the surrounding landscape. This can be a big plus in forested areas where trees would otherwise totally block the views.

HAZE

When shooting vistas—scenes that may extend for miles into the distance—it's not uncommon to encounter haze. This can ruin an otherwise great image by reducing the contrast on the more distant elements of the scene. As noted in lesson 36, using a polarizing filter can help.

LANDSCAPE MODE

If your camera has a landscape mode, this is the time to use it. If the shutter speed it selects is too slow to handhold, use a tripod (always a good practice on these shots, anyway).

> ### PROTECT YOUR EQUIPMENT
> It doesn't matter how careful you are, sooner or later your gear is going to hit the ground—and probably hard enough to make you wince. Whether it's because you slip or because your camera falls off a ledge you've set it on, it's going to happen. When it does, you'll wince a lot less if you've packed carefully.
>
> If you have the money to spend on one, most camera stores offer excellent padded camera bags (some in a backpack style perfect for hiking) that will help protect your camera and lenses from the damage that can be caused by a fall.
>
> If you're on a budget, sheets of foam from a fabric store can be wrapped around each piece and secured with a rubber band. Access to each piece won't be fast (but then, most landscapes aren't going anywhere).
>
> Oh—and if it's YOU that's falling, drop the gear and save yourself.

PANORAMICS

Sometimes a scene is just too grand to take in using a single frame. Consider creating a panoramic to tell a bigger story (see lesson 52).

VERTICALS

It may seem unintuitive, but don't forget to try vertical framing for a different perspective. This can work especially well with a beautiful sky.

Check your maps for roads designated as scenic highways—these often feature scenic vistas. When shooting, select the landscape mode on your camera for maximum sharpness out into the distance (facing page). Or, select the panoramic mode to shoot a sequence of images you can later combine into one (below).

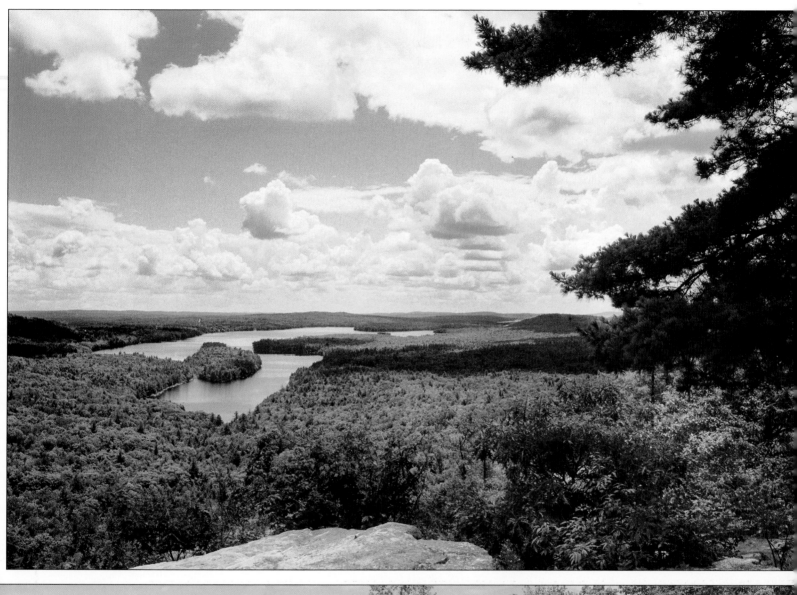
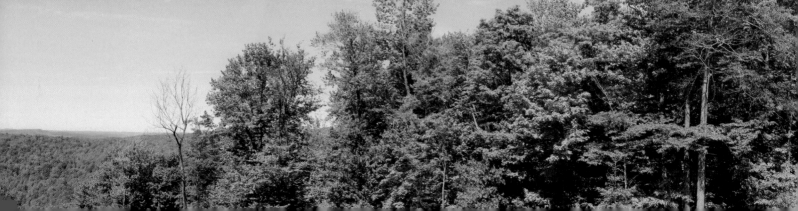

41. Deserts

If you're lucky enough to live in or get a chance to travel to one of the world's great deserts, don't miss the chance to photograph some truly beautiful landscapes. Even a quick trip to Las Vegas will provide lots of opportunities. Parks like Red Rock Canyon and Valley of Fire are only a few minutes away, and Death Valley National Park is an easy day trip.

TIME OF DAY

If you can manage it, try to do your photography in the early morning or late evening. At this time of day, the warmer color of the light is particularly flattering for the landscapes, which usually have more going for them in terms of shapes and textures than color. You'll also do yourself a favor by taking advantage of the somewhat cooler temperatures at these times of day. Don't forget to pack plenty of water for any trip to the desert.

EXPOSURE

Pack a few extra memory cards when heading out to do desert photography. These scenes tend to be high in contrast and can be tricky to expose. The bright lighting conditions can also make it hard to accurately preview images on your camera's LCD screen—so take a lot of shots, bracketing your exposures (see lesson 20), and sort out the best ones when you get home and can review them on your computer screen.

Deserts are wonderful subjects for landscape photographers. This image was taken in Death Valley National Park.

Both of these images were taken just a short drive outside of Las Vegas. Below is a scene from Red Rock Canyon and to the left is an image taken at Valley of Fire.

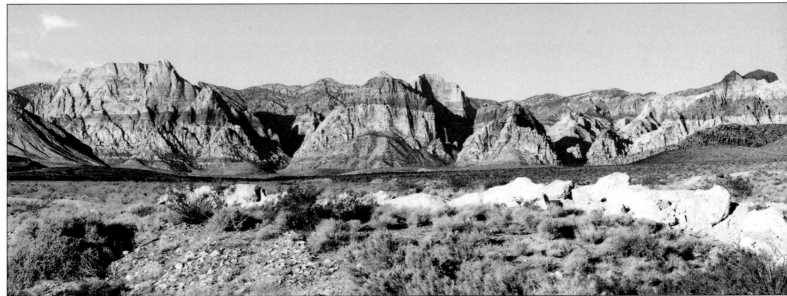

42. Aerial Images

If you have access to a small plane, aerial landscape photography can open up a whole new world for you. Aerial images have instant appeal because they show us the world in a way we just don't normally see it.

When planning to shoot aerial images, try to pick a very clear day with little atmospheric haze. The contrast- and color-destroying effect of haze gets worse over long distances. When you are shooting from a plane, your subjects are *all* pretty far away, so haze can actually affect your entire frame.

Another thing to watch out for is camera movement, which can cause blurred images. While the forward motion of the plane won't usually cause problems, vibrations from the engine can be an issue. To keep these from transmitting to your camera, don't rest the camera on any part of the plane while shooting. Instead, use your upper body and arms like shock absorbers to keep the camera stable.

Because your subject (the ground) is very far away, depth of field isn't a big concern. When using manual settings, therefore, you can use a wide aperture and fast shutter speed to reduce the impact of motion and vibrations.

Aerial landscape photos show the world in a unique way. Look for interesting patterns (like the rows of junked cars in the top image) and big or repeated features (like the river [right] and baseball diamonds [facing page]).

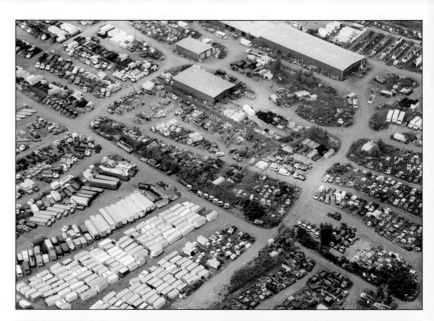

43. Digital-Imaging Software

WORKFLOW

Once you've taken a digital landscape image, the next step is to transfer that photograph to your computer. This can be done directly from your camera or by using a memory-card reader. Whatever method you choose, it's a good idea to burn a CD-R or DVD-R of all of your original files before you make any alterations to them. These are the digital equivalent of your negatives and you should protect them.

Once you've done this, you can move on to fine-tuning and outputting your images. In some cases, an image might be just the way you want it straight out of the camera. More often, though, you'll want to make at least some minor adjustments to improve the cropping, tweak the exposure, or even add some artistic enhancements. This is where digital-imaging software comes in.

ADOBE PHOTOSHOP ELEMENTS

There are literally dozens of brands and types of digital imaging software. In this book, we'll be looking at Adobe Photoshop Elements 2.0. There are a few reasons. First, it comes packaged with many digital cameras—and if it didn't come with yours, it costs under $100 to purchase it. Second, offering many of the tools included in Adobe Photoshop—far and away the most popular digital imaging software

The original shot (top) wasn't composed very well; notice the cut-off flower at the top of the frame. It was also a little dark and had a pinkish color cast. In Adobe Photoshop Elements, the problems were easily remedied to create the final image (bottom).

In Elements, the help files work just like a web site—you can search them, scroll through topics and instructions, and click links to related subjects.

among professionals—it's a very powerful imaging tool. Indeed, if you find that you like digital landscape photography so much that you want to invest in Adobe Photoshop, you'll find that the interface is almost identical to the one used in Adobe Photoshop Elements.

If you prefer to use a different type of digital imaging software, that's fine. Most programs allow you to accomplish similar tasks—they just tend to handle them in slightly different ways. If you see a technique here that you'd like to try with your software, consult your user's manual for instructions.

HELP!

Obviously, in the space allowed here it's impossible to provide comprehensive instruction on the use of Elements. If you get stuck or don't understand a step, don't hesitate to use the Help (accessed by clicking the question mark icon near the top right of the screen in Elements) and Hints (Window>Hints) files—they are excellent and offer easy-to-understand definitions and explanations. For further instruction, you can also consult one of the many manuals on the market for Adobe Photoshop Elements (including my own *Beginner's Guide to Adobe® Photoshop® Elements®*, also from Amherst Media).

Rather than looking at all the ways you can use this software, we'll look at some of the most useful techniques—the ones that are most commonly employed by landscape photographers. Don't let these be your limit, however. One of the best things about digital imaging is that it puts you in total control of your images. That's something most photographers haven't really experienced since color photography became the standard and we turned our negatives over to a lab to be developed and printed—so take advantage of the freedom!

44. Auto Color and Exposure Adjustments

If you're not quite satisfied with the exposure or color of your image, this is one of the first things you'll want to address. Elements offers several powerful tools to help you.

AUTO CONTRAST

The Auto Contrast tool (Enhance>Auto Contrast) adjusts the contrast of your image—and only the contrast. It will not help any color problems. If the contrast in your image seems flat or dull, this is a tool you could try.

AUTO LEVELS

Auto Levels (Enhance>Auto Levels) affects both color and contrast. This should remove any overall color cast—but it can also *introduce* a color cast where there wasn't one before. Still, it works well for many images.

AUTO COLOR CORRECTION

Auto Color Correction (Enhance>Auto Color Correction) works remarkably well on a lot of images. For many images, it will be all you need to get the color and contrast to a point that is quite acceptable.

ADJUST BACKLIGHTING

When the foreground isn't too badly exposed but the background is a lot lighter than you'd like it, the Adjust Backlighting (Enhance>Ad-

Go to the Enhance pull-down menu to access the auto correction features.

just Lighting>Adjust Backlighting) tool can often help by darkening the overexposed areas in the background.

FILL FLASH

When the background is well exposed but the foreground is too dark, you can use the Fill Flash (Enhance>Adjust Lighting>Fill Flash) to lighten these dark foreground areas.

BRIGHTNESS/CONTRAST

The Brightness/Contrast tool (Enhance>Adjust Brightness/Contrast>Brightness/Contrast) lets you adjust two sliders—one for brightness, one for contrast. Don't go overboard—it's easy to destroy delicate detail in the highlights and shadows of your image.

COLOR CAST

When you select this tool, a dialog box appears, and your cursor turns into an eyedropper. Click

Original image.

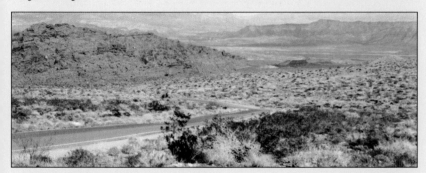

Image with Auto Contrast correction applied.

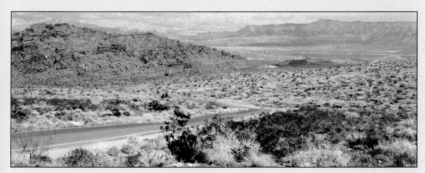

Image with Auto Levels correction applied.

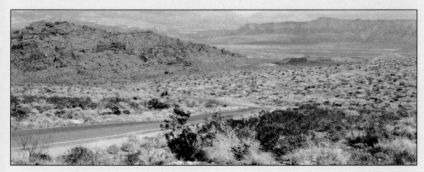

Image with Auto Color correction applied.

on any neutral (gray, black, or white) tone in the image to remove any color cast.

HUE/SATURATION

The Hue/Saturation tool (Enhance>Adjust Color>Hue/Saturation) allows you to select a range of colors from an image (say, all the reds) and adjust them without changing the other colors. To do this, select the color you want to change from the Edit pull-down menu at the top of the dialog box, then adjust the Hue slider to change the color.

COLOR VARIATIONS

This is a very useful tool for those new to color correction. When you open it, a large box appears showing you your "before" image in the top left and eight preview images at the bottom. Simply click on these to accept the change shown in the preview—and you can keep clicking box after box until your image looks just right (or, if you get off track, just click the Reset button to start over).

TRY THEM ALL

As you can see in the sequence of images to the left, the results you'll get with each tool will be slightly different—and not always good. Try them out and see what you like best. For more control, try the techniques in the next lesson.

45. Levels for Exposure and Color

The color- and exposure-correction tools we've looked at so far offer quick solutions to some problems. However, they don't provide much precision. To take control of the colors and tones in your image, you need to master Levels (Enhance>Adjust Brightness/Contrast>Levels).

When you open the Levels dialog box, the first thing you'll probably notice is a jagged black shape in a white window (right). This is called a histogram, and it is a graphic representation of the tonal values in your individual image. This gives you a totally objective way to evaluate your image.

Under the histogram are three triangular sliders. At the left is the black shadow slider, under the area of the histogram that shows dark tones. In the center is the gray midtone slider, under the area of the histogram that shows the midtones. On the right is the white highlight slider, under the highlight area of the histogram. The taller the histogram is above each area, the more of the tones in the image fall into that tonal range. By clicking and dragging these sliders, you can change the tonal range and contrast of your image.

At the top of the box is the Channel menu. There is one channel for each primary color in your image—red, green, and blue—as well as a composite channel for all three together (RGB).

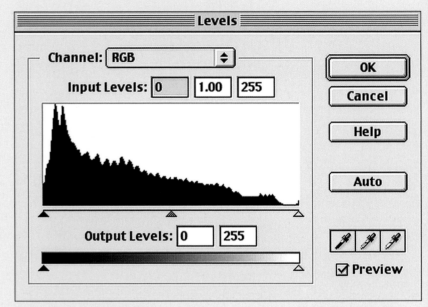

The Levels dialog box.

ADJUSTING CONTRAST

The overall tonal range and contrast of an image is sometimes easier to evaluate objectively using the Levels histogram. In the left image on the facing page, the low contrast of the photograph is obvious in the histogram below it, which shows that the tonal range of the image does not extend as much as it could into either the black or the white range.

The quickest way to improve the contrast is to move the highlight and shadow sliders. Begin by moving the shadow slider to the right until it is just under the edge of the histogram data (you can ignore any flat little tail of data that might stick out here, as seen in the middle

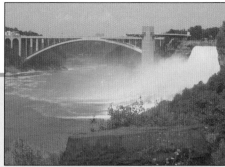
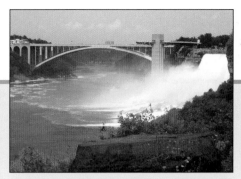
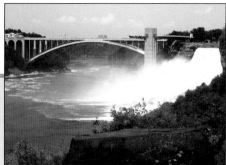

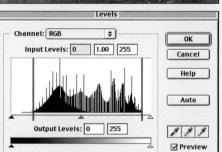
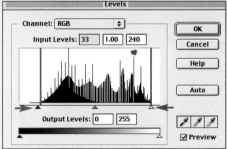
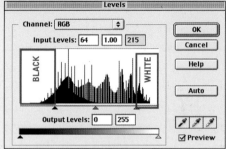

In the original (left), the histogram data stops short of the shadow and highlight sliders. This reveals that the tones don't extend completely from black to white, indicating a lack of contrast. Clicking and dragging the shadow and highlight sliders in under the very edge of the histogram data above them fixes the contrast (center). Don't move the sliders in past the edge of the histogram, though (right). If you do, you'll destroy highlight and shadow detail. All of the tones to the left of the shadow slider will be reduced to pure black; all the tones to the right of the highlight slider will be pure white.

screen shot above). When you do this, you're telling Elements that the darkest tone in your image (represented by that far-left end of the histogram) should actually be black. Similarly, moving the highlight slider to the left until it is just under the edge of the histogram data tells Elements that you want the lightest tone in your image to be white.

Don't go too far, though. When the shadow slider is moved in so far under the histogram, all of the image tones to the left of it in the histogram become pure black with no subtle detail. All of the tones in the histogram that fall to the right of the highlight slider become pure white with no detail. For most photos, this results in contrast that is too high and will not look at all good when printed, where the contrast becomes even more visible.

ADJUSTING THE MIDTONES

For many photos, a simple adjustment to the midtones (the tones the make up most of the image) can make a big improvement. To brighten the midtones in an image, click on the midtone slider and drag it toward the black point slider. To darken the midtones in an image, simply move the midtone slider toward the white point slider.

CHANNELS

You can also change the color balance of your image by choosing red, green, or blue from the channels pull-down menu and adjusting these same sliders. This method gives you great control, but it's also a bit complicated. For more details on this procedure, consult an Elements manual.

46. Sharpening and Softening

Sharpening and blurring are everyday operations with digital images. You can use them to improve flaws in an image or to enhance the appearance of your subject.

SHARPENING

If your image looks pretty much okay to the naked eye but a little fuzziness is apparent when you really get critical, sharpening may do the trick. Almost every scan of an image also requires at least a little sharpening to make it look as crisp as the original. Keep in mind, every image is unique and sharpening decisions are subjective.

To sharpen an image, go to Filter>Sharpen and select the tool you want to use. As noted below, some filters run automatically, while others require you to adjust their settings.

The Sharpen filter automatically applies itself to every pixel in the image or selection. It works by enhancing the contrast between adjoining pixels, creating the appearance of sharper focus. The Sharpen More filter does the same thing, but with more intensity.

The Sharpen Edges filter seeks out the edges of objects and enhances those areas to create the illusion of increased sharpness. Elements identifies edges by looking for differences in color and contrast between adjacent pixels.

The original image was scanned from a print and needed some sharpening.

Using the Unsharp Mask, the image was slightly sharpened.

Sharpen in moderation. Oversharpening your photos creates a look that is grainy and unattractive with light halos around dark areas, and dark halos around light ones.

Unsharp Mask is the most powerful sharpening filter in Elements. To begin, go to Filter>Sharpen>Unsharp Mask. This will bring up a dialog box in which you can adjust the Amount (how much sharpening occurs), the

The Unsharp Mask dialog box.

Radius (how far from each pixel the effect is applied) and the Threshold (how similar in value the pixels must be to be sharpened). To start, try setting the Amount to 150 percent, the Radius to 2 pixels, and the Threshold to 10 levels. Watch the preview and fine-tune these settings until you like the results.

Watch out for over-sharpening. If you're not sure you've sharpened an image correctly, go to Edit>Undo and compare the new version to the original. If the new one was better, use Edit>Redo to return to it.

Elements also has a Sharpen tool. This is used to "paint on" sharpness in selected areas and works pretty much like the other painting tools. The Select field in the options bar is used to set the intensity of the sharpening effect.

SOFTENING

Images from digital cameras are sometimes so sharp that they don't make delicate subjects look their best. For a gentle soft-focus effect, duplicate the background layer (Layer>Dupli-

cate Layer). Then, apply the Gaussian Blur filter (Filter>Blur>Gaussian Blur) at a setting of 3–5 pixels. Set the mode of the duplicated layer to Lighten (at the top of the layers palette).

The Gaussian Blur filter and the Blur tool (used just like the Sharpening tool, as described above) are also useful for making distracting elements much less noticeable.

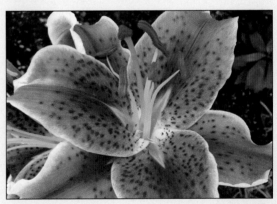

Original image.

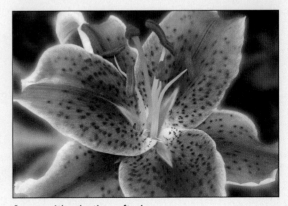

Image with selective softening.

47. Cropping and Vignetting

CROPPING

The Crop tool is used to remove extraneous areas from the edges of a photo. This is a great way to improve the look of photographs you didn't have time to frame carefully or didn't compose as well as you might have liked.

To crop an image, choose the Crop tool, then click and drag over the area of your image that you want to keep. You don't have to be incredibly precise. At each corner of the crop indicator (the dotted line) you will see small boxes. These are handles that you can click and drag to reshape or reposition the box. (As you get near the edges of the photo, these handles tend to "stick" to the edges. To prevent this,

> ### CROPPING AND RESOLUTION
> Cropping reduces the total number of pixels in an image. If you are working with a scanned image and know you plan to crop the image, you may therefore wish to scan your image at a higher resolution or enlargement to compensate for the reduction. If you are working with an image from a digital camera, the total number of pixels in your image is fixed, so you'll need to determine the final resolution and image size you need and be sure not to crop it to a smaller size than that.

click the handle, then press and hold Control while you move it.) When the cropped area looks right, hit Enter to apply the change.

The Crop tool can also be used very effectively to straighten a crooked image. Simply click and drag over the image with the Crop tool, then position your mouse over one of the corner handles until the cursor's arrow icon

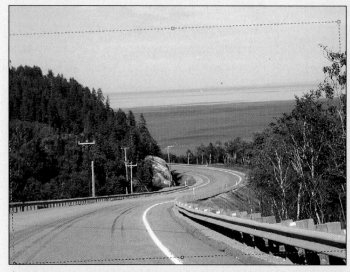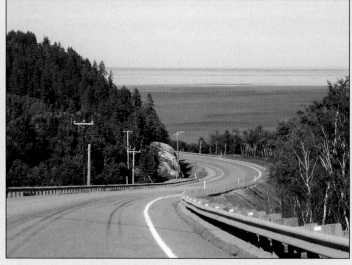

Cropping is a quick way to straighten out a crooked image, but you do lose some pixels in the process. Here, it's not a problem, but it could be more of an issue in other photos.

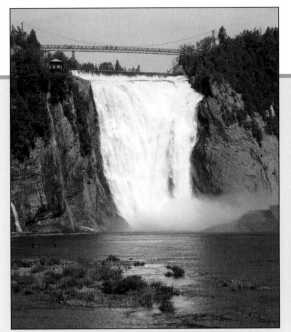
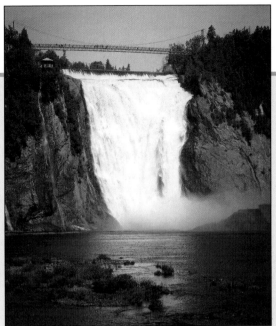

Vignetting (darkening the corners and edges of the frame) is one way to emphasize your subject and help keep the viewers' eyes from straying out of the frame.

turns into a bent arrow. Once you see this, click and rotate the crop indicator as needed. This may cause the edges of the box that indicates the crop area to go outside the edges of the image. If this happens, click and drag on each one to reposition them inside the frame.

In the options bar at the top of the screen you can set the final size of the image. This is helpful if, for instance, you specifically want to create a 4"x6" print to frame. Simply enter the desired height, width, and resolution needed before cropping, then click and drag over the image to select just the area you want in your print. The Crop tool will automatically constrain itself to the desired proportions.

Also in the options bar is a setting for the shield color and opacity. This shield obscures the area you are cropping out, giving you a bet-

ter idea of what the photo will look like with these areas removed.

VIGNETTING

Vignetting darkens the edges of the frame and can improve a composition by emphasizing the subject. To add a vignette, use the Elliptical Marquee tool to select an oval surrounding the subject of your image. Go to Select>Inverse to change to selection to everything *except* the subject. Go to Select>Feather to blur the edges of the selection by 50 to 100 pixels (the larger the number, the softer the edges). Create a new layer (Layer>New>Layer). With the selection still active, go to Edit>Fill and fill the selection with black. In the layers palette, adjust the opacity of the new layer to about 40–60 percent, creating a more subtle effect.

48. Using Filters

A filter is a specialized piece of software that runs within Elements and is used to apply a specific effect to an image. Many filters are packaged with Elements itself, and other filters (from Adobe and other companies) are also available to meet specialized needs. Filters offer instant gratification—and some pretty cool effects for your images. Be prepared to play with these for a while and marvel as they work a little magic!

To use any filter, go to the Filter menu. Pulling this down will reveal several submenu categories that each contain several individual filters. Select any filter to apply it. Some will apply immediately, some will open a dialog box and ask you to customize the settings for the effect you want.

You can also apply filters using the Filters menu from the palette well. After opening this palette, select All from the pull-down menu at the top to see all of the available filters and a thumbnail preview of the effect of each. When you see one you like, click and drag the thumbnail onto your image to apply the filter. Depending on the filter, this may also open a dialog box in which you can customize the filter's settings.

Not every filter will work well for every image—and a little goes a long way, so apply these filters selectively when an image needs a

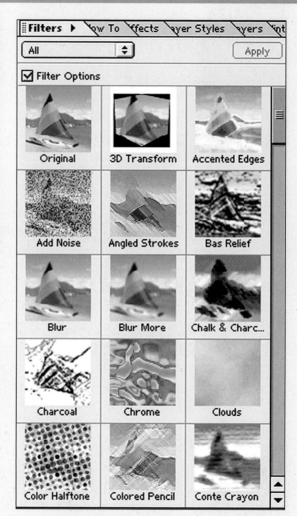

Filters menu from the palette well.

little extra "something" to get just the look you want. When you do use a filter effect, consider applying multiple filters or running the same filter more than once—this can sometimes create a very unique look.

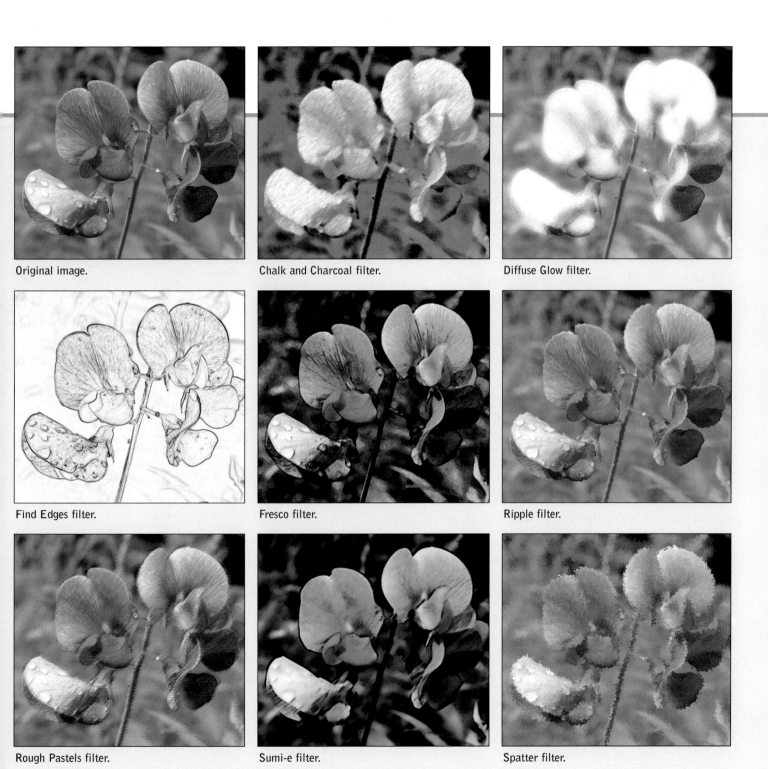

Original image.

Chalk and Charcoal filter.

Diffuse Glow filter.

Find Edges filter.

Fresco filter.

Ripple filter.

Rough Pastels filter.

Sumi-e filter.

Spatter filter.

49. Compositing Images

Originally, one of the most interesting uses for digital imaging was to combine elements of two images in a realistic way (called compositing). This was something that was extremely difficult with traditional photographic techniques. While it's no longer a primary reason to use digital-imaging software, compositing can still be a fun and creative exercise.

The criteria for selecting images to composite should be rigorous. For realistic results, the direction and quality of lighting should be very similar in both images. It helps, too, if all of the elements are well exposed and have no major color problems. Also, check to make sure the focus is correct. A softly-focused tree in the midst of a sharply-focused forest will not look realistic.

Look at the images carefully and decide which one contains more of the material you want to retain in the final image. In this case, the landscape (top right) will be the background. The only part of the other image that will be used is the bird (bottom right). Therefore, the material to be imported into the background photograph (the bird) was selected using the Lasso and Magic Wand tools—adding to and subtracting from selections as needed.

The selection was then feathered to soften the edges of the bird and make them a little less

The bird to the left will be added to the landscape shown above.

obvious when moving the selected subject into the landscape image. (Feathering the selection about 2 pixels is usually a good place to start.)

The selected area was then copied (Edit>Copy) and pasted (Edit>Paste) into a new layer in the landscape image.

Once this was done, the rest of the job consisted of fine-tuning the components to make them blend as seamlessly as possible. Correct positioning of the new element on the new layer was the first task. To do this accurately, look at the scale of the imported material. Does it need to be changed in order to make sense with the subjects around it?

Then, think about position. If your background image shows a vista, the subject must be positioned in relation to its apparent distance from the camera. If it's not, the viewer will immediately notice that something seems "fake" about the image.

Next, check the color, brightness, and contrast of the new element in relation to the background. Correct any problems using the Levels or one of the other image-adjustment controls.

When you're done, look critically at your work, watching for anything that looks out of place or unnatural (sharp or off-color edges on the pasted element are a common problem). When you are satisfied, flatten (Layer>Flatten Image) and save the photograph.

In the final image, the new bird now soars above the rocky peak.

50. Creating Black & White Landscapes

Many digital cameras feature a black & white shooting mode, but why limit yourself? It's easy to convert your images to black & white later—and you always have a color original to go back to if you decide that the black & white version isn't quite right. You might even end up wanting both a color image *and* a black & white one.

In Elements, there are several ways to convert an image to black & white. The easiest is just to go to Enhance>Adjust Color>Remove Color. You can also switch your image to the grayscale color mode (Image>Mode>Grayscale). Switching to grayscale sometimes creates a more neutral black & white result than using the Remove Color command, but you'll want to convert your image back to the RGB mode to print (Image>Mode>RGB). This won't add the colors back in but will construct the black & white tones in the way that most printers

When converting photos to black & white, you'll usually be happiest when you select images in which the shapes are more important than the colors.

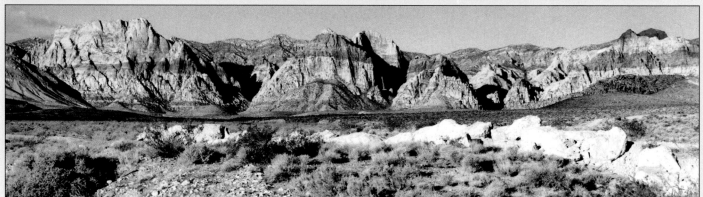

In most image-editing software, Dodge and Burn tools are included. The Dodge tool is used to lighten areas of your image that are too dark; the Burn tool is used to darken areas that are too light.

Often, these tools can be set to affect only one tonal range (the highlights, the midtones, or the shadows, for example). You can also usually adjust how intense the darkening or lightening effect will be. This may be noted as a percentage or exposure value.

In the first photograph (left), the background was hazy and too light—especially when considered in comparison to the foreground. To fix this, the Burn tool was used to darken the area, balancing it better with the foreground, as seen in the final photograph (right).

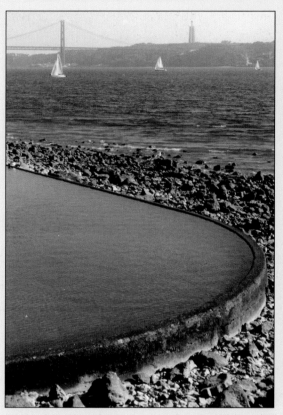

(both at home and in commercial photo labs) are set up to best handle them.

Once you've converted your image to black & white, look carefully at the tonal range. If you like, you can do this using the Levels histogram (see lesson 45). Frequently, images converted to black & white from color need a little contrast boost to make them look as crisp and engaging as the color original. If yours does, you can follow the instructions in lesson

45 to enhance the contrast or use the Auto Contrast tool (see lesson 44).

In some black & white photos, you may find that there are specific areas that are too dark or too light. In this case, try using the Dodge or Burn tool in your image-editing software (as seen in the images above). This tool imitates a traditional darkroom procedure that landscape masters like Ansel Adams employed to perfect their classic images.

51. Enhancing Color

CHANGING COLORS

The Hue/Saturation tool allows you to select a range of colors from an image (say, all the reds) and adjust them without changing the other colors. To do this, select the color you want to change from the Edit pull-down menu at the top of the dialog box. Then, making sure that the Preview box at the lower right is checked, adjust the Hue slider to change the color. The Saturation slider, below it, allows you to adjust the intensity of the color. The Lightness slider does just what its name suggests.

TONING

With the Colorize feature activated (at the lower right of the dialog box), the Hue/Saturation tool also lets you render an image in a monotone color—excellent for creating the

In the Hue/Saturation dialog box, Yellow was selected from the Edit pull-down menu. The Hue slider was then adjusted to turn the yellow tones red.

look of a sepia-toned image. To do this, click Colorize, then drag the Hue slide to the left or right until you like the color. When using this feature, it is often desirable to slightly reduce the saturation of the new color in the image.

HANDCOLORING

Handcoloring photos was traditionally accomplished with a variety of artistic media—oil

This puffin preserve in Maine is located on a rocky island and equipped with blinds for viewing the birds. Adding a sepia (golden brown) tone to the image helped suggest the rudimentary nature of the structures.

paints, pencils, etc. With Elements, you can create this classic look much more easily!

First, open an image. If it's a color image, go to Enhance>Adjust Color>Remove Color to create a black & white image. If it's a black & white image, make sure it's in the RGB mode, then go on to the next step.

Next, create a new layer (Layer>New>Layer) and set it to the color mode (from the Mode pull-down menu in the layers palette).

When you add your own colors to an image, you don't have to stick with natural ones—you can use your imagination.

Double click on the foreground color swatch in the toolbar to activate the Color Picker. Select the color you want and hit OK to select it as the new foreground color. This is the color your painting tools will apply. You may switch it as often as you like.

With your color selected, return to the new layer you created in your image. Click on this layer in the layers palette to activate it, and make sure that it is set to the Color mode.

Select the Brush tool and whatever size and hardness brush you like, and begin painting. Because you have set the layer mode to color, the color you apply with the brush will allow the detail of the underlying photo to show through.

If you're a little sloppy, use the Eraser tool (set to 100 percent opacity in the options bar) to remove the color from anywhere you didn't mean to put it. If you make a big mistake, you can always throw out the layer! Using the Zoom tool to move in tight on these areas will help you work as precisely as possible.

If you want to add more than one color, you may wish to use more than one layer, all set to the Color mode.

When you've completed your "handcoloring," the image may be either completely or partially colored. With everything done, you can flatten the image and save it as you like.

52. Panoramic Images

Panoramic images are created digitally by shooting a sequence of images and then combining them into one photograph.

SHOOTING THE IMAGES

To create successful panoramic images, you'll need to do some careful planning when setting up your shot.

You'll want to select a mid-range lens (neither telephoto nor wide angle)—this would be about a 50mm lens on a 35mm camera. If you are using a point-and-shoot with a zoom lens, set it about halfway out. It might seem like a good idea to use a wide-angle lens for panoramics, but this will cause distortion at the edges of images, making them difficult to join together seamlessly.

When you start shooting, select one exposure setting and focus setting and stick to it. The idea is to create the impression of a single image, and that won't happen if some sections

are lighter/darker than others, or if the focus suddenly shifts from the foreground to the background.

It's also important to maintain a consistent camera height (for best results, use a tripod and rotate the camera as you take each shot).

Let's imagine you are standing facing the part of the scene that you want to have on the left edge of your final panoramic. Lift the cam-

When you aren't careful about your lens setting, focus point, and exposure when shooting your original images, the software won't be able to seamlessly merge your photographs into a unified whole. The results might initially look okay, but when you zoom in, as seen in the circular area of the image to the left, the problems are very evident. The architectural elements just don't match up properly and the exposure on the floor is way off.

era and take the first shot, noting what is on the right-hand edge of the frame. Pivot slightly to the right and place the subject matter that was in the right-hand part of the first frame just inside the left edge of the second photo. Continue this process until you've taken enough images to cover the desired area. Ideally, you should have about a 10–20 percent overlap between the images.

If you're shooting digitally, check to see if your camera has a panoramic setting. If so, switching to this setting will usually change the display on the LCD screen so that you can see the image you are about to shoot and the previous image side by side, making it easy to set up each successive shot.

PHOTOMERGE

Once you've shot the images, combining them is a relatively simple procedure. When you go to File>Photomerge the first Photomerge window will open. Click Browse and select the images you want to merge. When all of the files appear in the Source Files window, hit OK and watch things start to happen.

When the second Photomerge window appears, Elements will try to place all of the photos in the correct position. If it can't, it will let you know. If this happens, the photos it can't place will appear as thumbnails at the top of the window. You can then drag them down into the main window and position them yourself. You can also click and drag the other images in the main window to reposition them if Elements doesn't do it correctly. When everything is in position, hit OK.

When the final image appears, it will usually have some uneven edges where the original photos overlap. Cropping the image will eliminate this and create the impression of a single image.

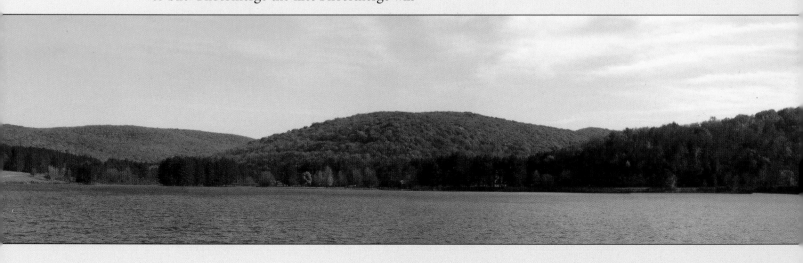

The Next Step . . .

Once you've mastered the basic concepts of landscape photography, it just comes down to practice. In order to improve, you need to get out with your camera and take a lot of pictures.

Visit your favorite outdoor locations—but take your camera with you other places, too. After all, many of the qualities that make a landscape image great (beautiful lighting, careful composition, etc.) also make other subjects look their best. Learning to pull all the image-enhancing qualities together in one shot is a skill you can practice on any subject.

Don't worry if—especially in the beginning—you have to take *a lot* of pictures to get one good one. Most people don't realize it, but even pros don't nail the shot every time. The big difference is, they edit their images carefully and only show the best of the best.

That said, once you've taken some shots, go home and look at them on your computer screen. Compare different images of the same subject and decide what you like about each one. Ask yourself what you could have done to correct any problems you find. If you have friends who are interested in photography, consider taking a photo excursion and comparing all your images afterward to see how different people shoot the same subject.

Finally, spend some time looking at the work of the masters. Master landscape photographers like Ansel Adams, John Sexton, and John Shaw have a lot to teach photographers of all skill levels.

Good luck!

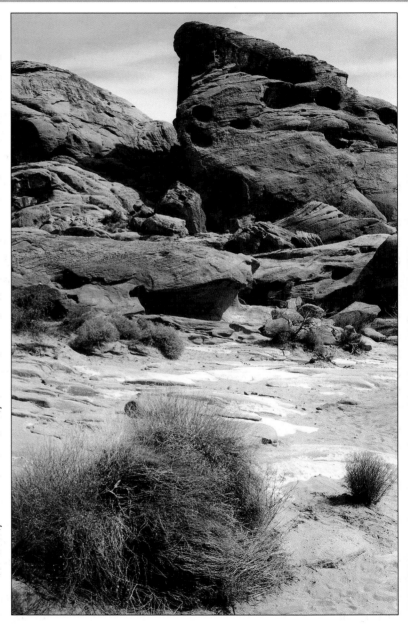

Index

PLEASE NOTE!
The numbers that are listed in the index refer to lesson numbers, not page numbers.